CW01215995

Presenting
MALAYSIA

Presenting
MALAYSIA

David Bowden

JOHN BEAUFOY PUBLISHING

jb

First published in the United Kingdom in 2016 by John Beaufoy Publishing, 11 Blenheim Court, 316 Woodstock Road, Oxford OX2 7NS, England
www.johnbeaufoy.com

Copyright © 2016 John Beaufoy Publishing Limited
Copyright © 2016 in text David Bowden
Copyright © 2016 in cartography John Beaufoy Publishing Limited
Copyright © 2016 in photographs David Bowden, except as listed opposite.

The author asserts his moral rights to be identified as the author of this work.

All rights reserved. No part of this publication may be reproduced, stored in a retrieval system or transmitted in any form or by any means, electronic, mechanical, photocopying, recording or otherwise, without the prior written permission of the publishers and copyright holders.

Great care has been taken to maintain the accuracy of the information contained in this work. However, neither the publishers nor the author can be held responsible for any consequences arising from the use of the information contained therein.

ISBN 978-1-909612-63-1

Design: Glyn Bridgewater
Cartography: William Smuts
Index: Krystyna Mayer
Project management: Rosemary Wilkinson

Printed and bound in Malaysia by Times Offset (M) Sdn. Bhd.

Front and back cover: A panoramic view of Kuala Lumpur © Erik Fearn.

Page 1: While not native to Malaysia, a species of hibiscus flower is the national flower of the country.

Page 2: The island of Langkawi appeals as a destination with immense natural beauty.

Page 3: The island of Penang has seen a street art-led tourism revival.

Page 5: The Batu Caves on the outskirts of Kuala Lumpur are a significant religious site for Hindus.

ACKNOWLEDGEMENTS

There are many people to thank for producing a book of this scope. The author acknowledges the editorial support provided by Ken Scriven and the aerial photographs provided by Erik Fearn.

PHOTO CREDITS

All photographs by David Bowden except for: p15 above (Mountain Torq), p25, p139 top (Sabah Tourism), p38, pp68-69, pp98-99, pp100-101, p107 (Erik Fearn), p47 (Shutterstock.com/Chen Ws), p51 top (Penang Global Tourism), pp64-65 (Mandarin Oriental), pp84-85 (Shutterstock.com/fiz_zero), pp102-103 (Shutterstock.com/Kjersti Joergensen), p130 (S.K. Chong), p133 (Resorts World Genting), pp136-137 (Shutterstock.com/Nokuro).

ABOUT THE AUTHOR

David Bowden is a freelance photojournalist based in Malaysia who specializes in travel, the hospitality industry and the environment. While Australian, he's been in Asia for longer than he can remember and returns to his home country as a tourist. When he's not travelling the world, he enjoys relaxing with his equally adventurous wife Maria and daughter Zoe. He is the author of several books in the *Enchanting* series produced by John Beaufoy Publishing.

CONTENTS

	Foreword	9
	Introduction	10
CHAPTER I	An Overview of Malaysia *Culturally Diverse, Naturally Alluring*	12
CHAPTER II	Kuala Lumpur and Surrounds *A Union of the Past and Present*	64
CHAPTER III	Negeri Sembilan, Melaka and Johor *Southern Gateway*	84
CHAPTER IV	North by North-west *States of Perak, Penang, Kedah (Langkawi) and Perlis*	102
CHAPTER V	East Coast and Central *States of Kelantan, Terengganu and Pahang*	124
CHAPTER VI	Sabah *The Land Below the Wind*	136
CHAPTER VII	Sarawak *Land of Hornbills and Headhunters*	148
	Resources	158
	Index	158

Opposite: The distinctive Kuala Lumpur Railway Station was built in 1910 in the Mogul style and has been renovated several times since, the last being in 2006.

FOREWORD MESSAGE BY THE
HONORABLE MINISTER OF TOURISM AND CULTURE MALAYSIA

I am pleased to pen a few words for David Bowden's *Presenting Malaysia*, a publication that captures Malaysia's many charms and attractions from the perspective of a well-travelled expatriate and award-winning writer.

Inside, you will catch a glimpse of some of our best tourist attractions – our million-year-old rainforests, vibrant cities and serene countryside, exotic culture and colourful festivals, and tropical islands and beaches. Nowhere else can you find such a unique and harmonious combination, which gives rise to our tagline Malaysia, Truly Asia.

Indeed, the slogan that's made the country famous worldwide aptly describes one of our strongest selling points – our cultural diversity. The shared history among the Malays, Chinese, Indians and local natives in the country has led to a harmonious amalgam of cultures, now an irresistible tourist attraction worldwide.

Presenting Malaysia, beautifully narrated in words and pictures, provides a strong introduction on Malaysia to those who have yet to visit the country. For those who have travelled its length and breadth, this book will be a sweet souvenir of your time with us here.

For us at the Ministry of Tourism and Culture, Bowden's latest publication is a wonderful reminder of our role and responsibility in the tourism development and promotion of the country. We continue our efforts to meet our targets of 36 million tourist arrivals with RM168 billion in tourist receipts by 2020. It is an ambitious endeavour, but one that we are confident of achieving with the synergistic participation from the private sector.

This book is a shining example of the public-private sector partnership in moving tourism forward. I look forward to a brighter future for Malaysia's tourism industry.

Thank you.

Malaysia Truly Asia

MOHAMED NAZRI BIN ABDUL AZIZ

INTRODUCTION

Indian chroniclers knew of the Malay Peninsula some 2,300 years ago and trading kingdoms existed here as long as 1,800 years ago. Malaya (the name of the country before independence) was ideally situated for maritime trade, which was then dominated by sailing vessels. Arab and Indian traders harnessed the south-west winds (appropriately known as the trade winds) to sail across the Bay of Bengal to north-west Malaysia as one of the first ports of call in Asia. They brought with them textiles from Gujarat and Bengal, which were exchanged for tropical products, such as camphor-wood, rhinoceros horn, gambier and other rainforest commodites. Chinese sailors used north-easterly winds to traverse the South China Sea southwards to the Malay Peninsula and the island of Borneo. At the same time caravans were crossing Asia along the various routes known as the Silk Road.

Ports and small kingdoms developed when landfall was made. The ancient Kingdom of Langasuka evolved on the peninsula in present-day Kedah and into southern Thailand around Pattani. Evidence suggests this kingdom dates back 1,800 years and had been influenced by Hinduism and Buddhism but at separate times.

Though archaeologists debate the exact date of human origins, the peninsula was populated well before this trade commenced by people known as the Orang Asli, who are thought to be descendants of tribes from southern Thailand. More intriguing is the fact that some Orang Asli speak a Mon-Khmer dialect similar to that of the Khmers (present-day Cambodia) and Vietnamese.

Malaysia's most recently proclaimed UNESCO World Heritage Site, the 399-ha (986-acre) Archaeological Heritage of the Lenggong Valley in northern Perak, has major cultural relevance as it offers one of the longest records of early man in one location. According to archaeologists, it is the oldest human site outside the African continent and its pre-history spans two million years. It is thought to have been located on the shores of an old lake and ancient riverbed and includes four archaeological sites in two clusters of open-air and cave sites. Its Palaeolithic tool workshop is evidence of early technology. These sites suggest a fairly large, semi-sedentary population with cultural remains from the Palaeolithic, Neolithic and Metal Ages. Its discovery has lead archaeologists to postulate that in the Palaeolithic Age the people of Lenggong were the first toolmakers who lived as hunters and gatherers. Bronze axes and jewellery unearthed here indicate that this is where metal was first used in Southeast Asia. In 1991, Perak Man dating back 11,000 years was discovered in the Lenggong Valley but stone tools found here have been dated to 100,000 years ago. Nearby in Bukit Jawa evidence of human occupation date the site to 200,000 years ago. Regional artefacts are displayed in the Lenggong Archaeological Museum at Kota Tampan.

Niah Caves in Sarawak contain human remains dating back 40,000 years. The limestone caves are located in Niah National Park 65 km (40 miles) south-west of Miri. The two main sites are Painted Cave and Great Cave close by. The former includes wall paintings that have been dated back 1,200 years.

Trade over thousands of years has been the prime factor in the development of both the peninsula and Borneo leading to the colonization of the country by various nations, of which the last was Britain which remained in power for much of the time from 1795 to 1957. Nationalistic forces developed in Malaya after the Second World War. On August 31, 1957 it became independent of British colonial rule and the new nation of Malaysia emerged. The ceremony took place in central Kuala Lumpur on the Padang at what is now known as Dataran Merdeka (*merdeka* meaning independence). With three cries of '*Merdeka, Merdeka, Merdeka*' Malaysia announced itself to the world.

Separated by a vast expanse of the South China Sea, the East Malaysian states of Sarawak and Sabah on the island of Borneo joined the Malaysian Federation in 1963. Known for their rainforests, a menagerie of wild animals and cultural diversity including tales of headhunting, both Sarawak and Sabah are very different from the peninsula. Both maintain some autonomy from the national affairs of state including administering their own immigration controls.

Malaysia is now a rapidly developing Asian nation of 28.5 million people. Its mix of multiculturalism and its range of natural areas from beaches to islands and mountains to rainforests make the country a popular holiday destination with over 25 million visitors arriving annually. Its diverse natural environments support many unusual animals and plants which add to Malaysia's holiday appeal.

CHAPTER 1

An OVERVIEW of MALAYSIA

A Truly Asian Experience

For years, Tourism Malaysia has promoted the country to the world as *Malaysia Truly Asia* because it sums up the multicultural experience that the country offers visitors. An exciting destination that retains many elements of its diverse history and culture while having cities as modern and contemporary as anywhere else in Asia, Malaysia's multiculturalism is reflected in its music, fashion, architecture, design, art, food, handicrafts, customs and religious beliefs.

Left: Kuala Lumpur's Jalan Alor is the most famous food street in the city. Dining out in the open to enjoy the tropical ambiance is one of the great delights of visiting Malaysia.

AN OVERVIEW OF MALAYSIA

Malaysia is a federal constitutional monarchy. There are 13 Malaysian states as well as the federal territories of Kuala Lumpur (the capital), Putrajaya (the new and planned administrative centre south of Kuala Lumpur) and Labuan (an island off the west coast of Sabah that operates as an offshore financial centre). Nine of these states have hereditary royal families headed by sultans, who once ruled the land but whose role is mostly ceremonial these days. The King, or Yang di-Pertuan Agong, is elected for a five-year reign by the nine rulers who constitute the Conference of Rulers. Like the sultans of the nine royal states, the King's role is also ceremonial with the day-to-day running of the country being left to the Prime Minister and the democratically elected government of the day. The King's official residence is the Istana Negara located near the centre of Kuala Lumpur on Jalan Tuanku Abdul Halim (formerly Jalan Duta).

The Malaysian population comprises Malays, Chinese, Indians and some 30 other racial groups from the Orang Asli aborigines on the peninsula to Eurasians and the many different tribal communities in East Malaysia, such as the Ibans and Kadazans.

Interestingly, Malaysia is still considered by the International Monetary Fund (IMF) to be a developing country economically. Development is measured by various criteria including Gross Domestic Product, Gross National Product, per capita income, the level of industrialization and general standard of living. Many visitors may wonder about this when they see numerous luxury cars, modern condominium blocks in the capital and the luxury boutiques in Kuala Lumpur's prestigious and cavernous shopping malls. However, Kuala Lumpur is not representative of the whole country and there are some remote areas where families still live semi-subsistence lifestyles.

Malaysia is, in fact, one of the fastest growing economies in the region with expanding industrial and services sectors. Tin and rubber were once the mainstays of the economy but now petroleum and gas, palm oil, manufacturing, forestry, chemicals, semi-conductors, electronics and tourism make the greatest contributions to the economy.

GEOGRAPHY

Malaysia is a Southeast Asian country that comprises the Malay Peninsula (or West Malaysia or just peninsula) and the East Malaysian states of Sabah and Sarawak situated in Borneo; the world's third largest island. These parts of the country are separated by 600 km (370 miles) of the South China Sea. Malaysia covers an area of 333,000 sq km (127,413 sq miles), of which West Malaysia accounts for 40 per cent of the total area, Sarawak 37 per cent and Sabah 23 per cent.

The country shares borders with Thailand, Singapore, Brunei, Indonesia and the Philippines. Its shoreline extends along the Straits of Malacca and forms the maritime border with the Indonesian island of Sumatra as well as the island nation of Singapore. These straits are one of the world's busiest waterways. Malaysia is bordered by the South China, Andaman, Celebes and Sulu Seas.

HABITATS AND FLORA

The highest peak on the peninsula is Mount Tahan at 2,191 m (7,188 ft) situated in Taman Negara National Park, while the highest mountain in Malaysia is Mount Kinabalu (4,095 m/ 13,435 ft) in Sabah. Malaysia's longest rivers are the Pahang on the peninsula at 475 km (295 miles), the Kinabatangan (560 km/ 348 miles) in Sabah and the Rajang (563 km/350 miles) in Sarawak.

Because Malaysia straddles the Equator, there is a notion that much of Malaysia is covered in dense tropical rainforests, however, while there are still large expanses of primary forests, the landscape ranges from highly urbanized cities to remote offshore islands.

Above: The rugged peak of Mount Kinabalu in Sabah is the highest mountain in Malaysia.
Opposite: The King of Malaysia lives in a grand, recently built palace within a few kilometres of the centre of Kuala Lumpur.

AN OVERVIEW OF MALAYSIA

On the peninsula primary rainforests cover much of the central Titiwangsa Range, while Taman Negara National Park protects 434,300 ha (173,720 acres) of mostly lowland dipterocarp (meaning plants with two winged-seeds) forest. The World Wide Fund for Nature (WWF) estimates that just 38 per cent of the original primary forest remains on the peninsula. In East Malaysia, despite vast agricultural expansion in the form of rubber, acacia and oil-palm plantations, Sabah and Sarawak still have extensive forested areas many of which are protected as national parks. Conservationists consider Malaysia's natural habitats to be a treasure trove of species many of which have not yet been identified. As such, they suggest that no one really knows the medicinal and economic potential that lies within these habitats. WWF recently reported that in one year's research 52 new animal and plant species were identified by scientists in Borneo alone. This includes 30 fish, two tree frogs, 16 gingers, three tree species and one large-leafed plant. One of the fish recently identified, the *Paedocypris progenetica* found in Malaysian Borneo and the Indonesian island of Sumatra, is now considered the world's second shortest vertebrate.

Above: While tropical rainforest has the image of being dense and impenetrable, it is only so where the sunlight breaches the overhanging upper storey and canopy.
Left: Dipterocarp plants are so-called because of their two-winged seed.
Opposite: Although Malaysia is no longer covered in vast tracts of lowland dipterocarp forests, there are still many reserves and national parks where visitors can explore such habitats.

AN OVERVIEW OF MALAYSIA

Above: Forest surveys in the lowland forests of Malaysia indicate that 55 per cent of all large tree species belong to the dipterocarp family.

Right: Emergent species in the rainforest exceed the average canopy height of 40–45 m (131–148 ft).

Opposite top left: High rainfall in rainforests depletes the soil of nutrients but buttress or aerial roots enable tall trees to obtain whatever food there is in the uppermost layer of soil.

Opposite top right: Palms from the tropical rainforest are still used extensively for medicines, food, weaving and building materials.

Opposite below: While it is inherent in the name; rainforests are an important source of water and a filter for the rain that falls over them.

AN OVERVIEW OF MALAYSIA

Scientists have categorized 14 different forest formations within the broader classification of tropical rainforest. Lowland dipterocarp is the primary forest in much of the country. Giant emergent trees, such as the Tualang, penetrate the dense canopy while an understorey includes vines (like *rattan*) and lianas that wrap themselves around the smaller trees. Colourful ginger plants flourish in the understorey as does the rafflesia; the world's biggest flower. The humid conditions favour orchids, ferns and epiphytes, which contribute to the tropical rainforest being the richest in total number of species supported of any habitat on earth.

Left: Epiphytes are commonly found in rainforests where they grow on other plants for support. Unlike parasites, they obtain their own water and nutrients, merely using the host for support.
Below: Flowering plants, such as epiphytic orchids, also flourish in the tropical rainforest. As they require light, they normally grow where there is a break in the forest canopy.

Mangrove forests and other wetlands line parts of the coastlines specifically on the West Coast of the peninsula but population pressure and development have reduced many to a shadow of their former selves. Freshwater and peat swamp forests also occur on riverine and coastal plains. These habitats serve important ecological functions in protecting the coastline from erosion as well as being a source of building materials, a habitat for plants and animals (especially resident and migratory birds) and a spawning ground for fish and crustaceans.

Above: Mangroves adapt to their harsh environment through using aerial roots to obtain oxygen.
Left: Tree ferns with long stems and dissected leaves are a common feature of montane forests which flourish in the higher altitudes (above 1,200 m/3,937 ft).
Above left: Gingers are perennial herbs, although the ornamental ginger (pictured) is introduced to Malaysia.

The coasts of the peninsula and the islands are lined with beaches of which the long sandy stretches that occur along the East Coast of the peninsula are the most significant. Beach resorts have been developed on the best beaches, such as at Cherating.

From Kuala Lumpur northwards and well into southern Thailand the landscape is dominated by limestone outcrops known as karst topography. Rounded hills and steep-sided limestone outcrops dot the landscape and support vegetation that is able to survive in the shallow soils that form here. They are home to a large number of plants and of the 261 vascular plants that live on limestone soils, half are endemic to this habitat. Karst outcrops are particularly obvious around Ipoh where several temples have been built in the large caves that form in limestone rock. This habitat is under threat as some outcrops are quarried for the limestone used in the cement industry. In East Malaysia, some of the world's largest caves are located in the limestone formations beneath Sarawak's Gunung Mulu National Park.

Temperature decreases and moisture increases with altitude and at altitudes of 1,200 to 1,500 m (3,937 to 4,921 ft) hill dipterocarp forest changes to lower montane forest. Conditions on peaks such as Mount Kinabalu and those in the Cameron Highlands and Fraser's Hill on the peninsula are cold enough for lower-montane and montane forests to develop. The canopy is much lower and epiphytes, orchids, mosses and rhododendrons thrive in the cool conditions. However, the summit of Mount Kinabalu at Low's Peak is so harsh that few plants survive.

This page: Most Malaysian beaches are sandy and backed by coconut palms (left) or casuarinas, and are popular for recreation.
Opposite: Outcrops of near-vertical limestone, called karst topography, surround the city of Ipoh.

HABITATS AND FLORA

AN OVERVIEW OF MALAYSIA

Heath forest or *kerangis* (an Iban word which means where rice will not grow) forest develops in acidic soils that are depleted of base minerals. One of the best places to see such forest is in Bako National Park in Sarawak near the state capital of Kuching. Plants such as nepenthes (pitcher plants) have adapted to the nitrogen-deficient habitats such as heath forest (also swamp, peat and exposed mountain habitats) by becoming insectivorous. Malaysia's 30 pitcher plant species are able to lure, trap and digest small insects.

Right: Pitcher plants thrive in mineral-deficient soils such as the peaty or swampy habitats in the lowlands and exposed mountain summits.

Below: Heath forest is known in Malaysia as *kerangas,* which is an Iban word for 'land on which rice will not grow' due to it being highly acidic with few base minerals.

RAFFLESIA

The world's largest flower survives on the floor of some Malaysian rainforests. It starts as a small, ball-shaped bud that may lie dormant for months before opening as a five-petalled flower measuring up to a metre (three feet) in diameter. The flower only lasts for about five days. There are eight species of rafflesia in Malaysia with *R. arnoldii* being the world's largest. The rafflesia has no leaves, roots or stem and is parasitic on a vine called Tetrastigma. It smells of rotten meat and attracts flies, which carry pollen between male and female plants. Because it blooms for such a short time (and cannot be cultivated), it is difficult to see a rafflesia in flower but Poring Hot Springs, Kinabalu Park and the Rafflesia Information Centre in Sabah, and Cameron Highlands on the peninsula are the best places for a possible viewing.

FAUNA

Malaysian fauna is impressive; 280 of Southeast Asia's 300 mammal species (40 per cent of which are bats and 30 per cent rodents) have been identified in the country. While it is the mammals that attract most of the attention, Malaysia's animal life is very diverse and includes over 1,000 species of butterfly, 140 snakes and 165 species of toad and frog. Unlike on the more open African savannah, wildlife spotting in the tropical rainforest is never easy as the animals are well hidden and camouflaged.

Asian Elephants on the peninsula and Pygmy Elephants in Sabah are the largest mammals in the land, while the Sumatran Rhinoceros is one of the rarest animals on earth. Rhinos survive in reserves such as Sabah's Tabin Wildlife Reserve and Endau-Rompin Park on the peninsula but in such few numbers that even the rangers rarely see them. Being endemic to Borneo and with possibly only 2,000 Pygmy Elephants remaining in the wild, trans-boundary parks (those that extend over international borders) are important for animals that inhabit the forests and roam across the border between Sabah and Indonesian Kalimantan.

Below: The Sumatran Rhinoceros is now considered extinct so the only opportunity to see one in Malaysia is in captivity.
Opposite top: The Proboscis Monkey, so named for its prominent nose, is only found in the wild on the island of Borneo, where it is locally common.
Opposite below left: The Silvered-leaf Monkey or Silvery Lotung is common in riverine habitats in Malaysia.
Opposite below right: Long-tailed Macaques are the most common monkey in Malaysia and live on the fringes of urban areas even in central Kuala Lumpur.

FAUNA

Primates live in many habitats and are some of the most commonly sighted animals, usually in groups, although Orangutans tend to be solitary. There are three groups of monkeys: leaf monkeys (langurs), macaques and the distinctive Proboscis Monkey. The Long-tailed Macaque is the most common and it can be seen swinging and jumping through the trees even in urban areas where its foraging in unsealed garbage bins can create havoc. Pig-tailed Macaques may be seen in

AN OVERVIEW OF MALAYSIA

places such as Sabah's Kinabatangan Reserve or occasionally in villages where the young are trained to climb palms to retrieve coconuts. The rarest is the Stump-tailed Macaque which lives in the forests of Perlis on the border with Thailand.

Dusky Leaf Monkeys (Spectacled Langurs) are more docile and therefore not seen so often. They survive in groups of 10 to 15 with the young being distinctly orange in colour in contrast to the grey-black of adults. One of the lesser apes, the Siamang (a gibbon), uses its long arms to swing through the trees and is often heard making 'whooping' sounds that boom through the forests early in the morning.

Another fascinating Malaysian primate is the Proboscis Monkey named after the pendulous red nose of the adult male (they are also known as the Long-nosed Monkey). They are only found in Borneo, mostly within mangrove forests, and with numbers declining, they are listed as endangered by the International Union for Conservation of Nature (IUCN). They are surprisingly large animals – the males attain a height of 70 cm (27½ inches) – but this doesn't affect their agility as they leap from branch to branch. They mostly live in families of about 20 and the lead male is known to make threatening gestures to those who approach his harem.

Being mostly orange and red with grey limbs, it's easy to spot them in the foliage. On the ground, they mostly walk semi-upright and water is no obstacle as they are also good swimmers. The distinctive male belly led Indonesians in Kalimantan to call them *Monyet Belanda* or Dutch Monkey, as it resembled the posture of some of the Dutch living there.

Malaysia's best-known primate is the Orangutan, which is only found on the islands of Borneo and Sumatra (in Indonesia). The Malaysian name for Orangutan means 'forest man' and as such, gives two of the few Malaysian words to be found in the English language. These orange-coloured apes live in the forests of Sabah and Sarawak but their habitat is threatened by agricultural expansion and forest clearing and they are now one of the world's most endangered species. Current population estimates in Sabah are 10,000 to 20,000 (figures vary widely). While adventurous tourists could sight them in the wilds of Sabah's Kinabatangan River most will see them in reserves such as Sepilok near Sandakan and Matang near Kuching. These wildlife reserves were established to re-train orphaned juveniles to survive in the forests.

Orangutans are solitary, tree-dwelling primates that mostly live in rainforests below an altitude of 1,000 m (3,281 ft). Males live an entirely solitary life, meeting with a female partner purely for the purpose of mating while the female lives with her young until they are about six years old. The feeding range of an adult Orangutan is rarely more than 6 sq km (2⅓ sq miles) and the daily feeding range is usually less than 1 sq km (under half a square mile). Their diet consists mostly of forest fruits but also includes leaves, bark, flowers and insects. One study discovered that their diet includes over 100 plant species. An adult female can weigh from 35 to 50 kg (77 to 100 lb), while a fully-grown male is heavier; some are as heavy as 100 kg (220 lb), with a height of 1.4 m (4½ ft) and a reach of 2.4 m (8 ft). The life span of an Orangutan is about 30 years.

Above: Adult male Orangutans have large, distinctive, fat-filled cheek pads.

Opposite: While young Orangutans may be seen alone, they stay close to their mothers for the first two years of their life, becoming fully independent between seven and nine years old.

AN OVERVIEW OF MALAYSIA

Malaysia has eight members of the cat family with the Malayan Tiger being the largest. It is only found on peninsular Malaysia but, according to WWF, numbers could be as low as 250 individuals due to poaching and deforestation. Priority conservation areas for the tiger are Belum-Temengor, Taman Negara and Endau-Rompin. The Clouded Leopard is an arboreal and nocturnal cat, which is usually found in pairs and which hunts other forest animals.

Southeast Asia's only bear, the Honey Bear or Malayan Sun Bear lives in Malaysian forests. While it has a fondness for wild honeycombs and bee larvae, the bear is basically a meat-eater consuming earthworms and termites. This mostly diurnal and solitary animal is a powerful climber and rests in a tree nest.

The black and white-coloured Tapir with a trunk-like protuberance is one of the more unusual herbivores. Fossil evidence suggests the species was once more widely distributed but is now only found in Southeast Asia and South America. Confined to the peninsula, this mostly nocturnal and solitary animal eats a variety of plants and roots.

Below: Malaysia's largest cat, the tiger, is totally protected because of its rarity and vulnerability. It is classifed as 'Critically Endangered' and is only found on Peninsular Malaysia.
Opposite: The Seladang or Gaur has a range from India to Peninsular Malaysia but is not found in the East Malaysian states of Sarawak and Sabah.

The Seladang or Gaur is the world's largest wild ox and may be seen by observant visitors from hides within Taman Negara. It can be found in other countries in the region, though its ecological status in Malaysia is threatened by poaching and forest habitat destruction.

Many of the birds in Malaysia are camouflaged, small and agile. Many species are resident while others are migratory, passing through the country on annual north-south migrations. One of the interesting migrations is that of the Honey Buzzard which crosses the narrowest part of the Straits of Malacca (38 km/24 miles) around the 16th-century Portuguese Cape Rachardo Lighthouse near Port Dickson in September (going south) and March (going north).

Brilliant blue kingfishers are commonly sighted darting low above rivers. Waterbirds include egrets and herons, which can be seen fishing in river shallows and mangroves. Large White-bellied Sea Eagles with long talons can also be seen swooping onto hapless fish. The Langkawi wetlands are a good place to sight these and the Brahminy Kite. Popular birdwatching sites in the country include Kuala Selangor, Fraser's Hill, Taman Negara and Mount Kinabalu.

Sepilok's forests are an excellent location to sight the Borneo Bristlehead for example, one of 673 bird species found on Borneo. It's also one of the 61 bird species found only of the island of Borneo.

Hornbills with their prominent casques (a projection from the top of their large bill) are some of the most distinctive birds in Malaysia. Their casques were once highly tradable items that were carved in a similar fashion to ivory. These large birds swoop from tree-tops to lower branches with a flourish of wing flapping and loud calling. Their nesting habits are also intriguing as the female is plastered inside a tree hollow by the male who then feeds her and the chicks when they hatch.

Swifts and swiftlets are commonly associated with caves. These birds are important ecologically as they help keep insect populations in check and one of the best locations to see this at work is the evening exodus of the millions of birds from the caves in Gunung Mulu National Park. Edible nests of the Black-nest Swiftlet and White-nest Swiftlet are highly prized for Chinese cooking with the latter nests being the more valuable. Gomantong Caves in Sabah offer visitors an opportunity to see nests being collected by villagers.

Left: Yellow Bitterns feed on amphibians, fish and insects mostly caught around wetlands.

Below: Brahminy Kites are commonly seen hunting around open stretches of water with those of the Langkawi Geopark offering guaranteed sightings.

Opposite top left: Of the world's 54 species of hornbill, the Oriental Pied Hornbill, is one of ten species recorded in Malaysia.

Opposite top right: The bar on the throat of the Wreathed Hornbill gives rise to its alternate name, the Bar-pouched Hornbill.

FAUNA

Above: All the six egrets, including the Intermediate Egret, are migratory and winter in Malaysia.

Left: Before the breeding season, the head, neck and chest of the Cattle Egret becomes rufous-buff.

AN OVERVIEW OF MALAYSIA

Malaysia has a long list of reptiles and amphibians from snakes to lizards, frogs, turtles and crocodiles. Monitor Lizards can be seen stalking across the land or swimming proficiently in water. On the island of Langkawi, the soft sands are home to Butterfly Lizards which can be seen scurrying from burrows across the sand. The House Gecko or cik cak is commonly seen throughout the country darting up and down walls and keeping household insect populations in check.

Malaysia has two crocodile species – the Saltwater (or Estuarine) Crocodile and the False Gharial. Male adults of the former are large (the largest caught was 5.6 m or 18 ft and weighed 1,250 kg/2,756 lb), live along the banks of rivers and occasionally attack humans. The False Gharial has a long, narrow snout and prefers living in freshwater, such as inland swamps. There have been recorded attacks on humans by the False Gharial but these are rare.

Turtles are marine animals that many tourists seek out on holidays to Malaysia. Malaysia is part of the Coral Triangle, a vast area of tropical waters from Malaysia in the west, the Solomon Islands in the east, Indonesia in the south and the Philippines in the north. Four marine turtles are found in Malaysian waters – Leatherback, Green, Hawksbill and Olive Ridley. There are several turtle hatcheries around the country including Cherating, Melaka, Redang Island and Turtle Island in the waters off Sandakan, Sabah.

Below: The Water Monitor uses its tongue to detect smells in its environment.

COMMERCIAL CROPS

The rubber tree (right) was the first plant to be established as a plantation crop in Malaysia. Introduced from South America, it thrived in the tropical climate as did the oil palm when it was introduced from West Africa and established commercially in 1917. There are now 4.5 million ha (10 million acres) under oil-palm plantation, producing 17.8 million tonnes (19.6 million tons) of palm oil annually. Malaysian palm oil satisfies 11 per cent of the world's total oil and fat needs.

Rice is another important crop generally grown commercially, although there are smallholders around Malaysia who grow rice for their own family consumption. It is grown throughout the country with Perlis and Kedah being known as the 'rice bowl' states. While once hand-planted and harvested, this is now mostly done by machines (below). One interesting rice variation is Bario rice grown by the Kelabit people in Sarawak's cooler Kelabit Highlands. This brown rice is only planted once a year and considered a delicacy.

CLIMATE

Malaysia straddles the Equator (between 10 and 7o°N) and has a climate that is hot and humid year-round. Diurnal and monthly temperatures have a small range and are basically a straight line with temperatures ranging from 20°C (68°F) to 30°C (86°F). Humidity is always high especially just before monsoonal showers. Relief arrives with the monsoon rain; the seasonal reversal of the winds that were once important for sailing ships crossing oceans. Peninsular Malaysia was known as 'The Land Where the Winds Meet' and Sabah as 'The Land Below the Wind'.

It mostly rains on the West Coast during the south-west monsoon from May to September and on the East Coast from November to April with the north-east monsoon. Typically in the monsoon season, there is a build up during the day and by mid-afternoon, the clouds release a heavy deluge, then the sun returns soon afterwards. Flash flooding is common and if it happens over an extended period, low-lying areas become more permanently flooded. This daily and seasonal rainfall is an essential component of tropical life with plants being as dependent on it as they are on the high temperatures and humidity.

With few options available, the colonialists sought refuge in the mountains where hill stations were established in the cooler air. The first was on Penang Hill, then others opened at Fraser's Hill, Cameron Highlands and Maxwell Hill (Bukit Larut). Their importance has declined over time, although the Cameron Highlands is still a popular holiday destination.

In homes, outside temperatures were originally moderated through the use of shuttered windows and large bamboo blinds which offered protection from direct sunlight. Village homes were, and often still are, built on stilts to allow air to circulate. *Attap* (thatched fronds from the Nipa Palm) roofs also helped keep traditional homes cool.

An official building by-law implemented in 1884 made the 'five foot walkway' obligatory. This covered thoroughfare at the front of buildings was introduced as a shaded footpath for pedestrians but also helped to keep the ground floors of buildings cool. Five-foot walkways are still evident in many Malaysian cities and towns, although most have been commandeered by shopkeepers as a space in which to sell their products or by restaurateurs to set up tables and chairs. Today, Malaysians enjoy modern comforts with most buildings being air-conditioned or fan-cooled.

Opposite: While Melaka (Malacca) was once one of the region's dominant ports, it is now more important for tourism due to its UNESCO status.

Below: 'Five foot walkways' were introduced in colonial Malaya to protect pedestrians from the sun and rain.

HISTORY

PENINSULAR MALAYSIA

Malaysia's strategic location along several major maritime trade routes linking the East and the West ensured that various ports within the country became integral to this regional and international commerce. Literary references are basically all that exist of these ancient ports as there are few tangible remains. The ancient Tamils called the Malay Peninsula Suvarnadvipa

or 'Golden Peninsula' and it is shown on the ancient Greek geographer and astronomer, Ptolemy's map as the 'Golden Chersonese'. According to the *Sejarah Melayu* (Malay Annals) a Khmer (Cambodian) Prince founded a kingdom in present-day Perak. Chinese chronicles also made mention of a great port along the Straits of Malacca (probably in the neighbouring island of Sumatra).

Products principally from India and China were shipped via the coastal ports of the peninsula through the Straits of Malacca or from ports fronting the South China Sea. Malacca (now spelt Melaka, although the old name is still used for the Straits of Malacca) was founded by Prince Parameswara from neighbouring Sumatra and developed as a trading entrepôt in the late 14th century to become one of the world's busiest ports of that era. Significantly, Melaka is situated at one of the narrowest parts of the straits. Muslim Indian traders were attracted here and Parameswara converted to Islam in the early 15th century. (He was not the first Muslim ruler in the land as evidence in Kuala Terengganu suggests that Raja Mandulika proclaimed Islamic law some 25 years before.)

Over time, Melaka was surpassed by Penang and Singapore, though the city retains many of its heritage buildings and visitors will be able to gain an insight into its former glory. Many of these remaining structures in and around the port were established by the colonial powers that controlled the port of Melaka.

As early as the 16th century, private chartered syndicates were created within European nations, such as Portugal, Holland, Britain and France, to develop trading links with Asia. Trade had to be protected during the European Age of Discovery, with the result that vast navies were amassed and fortified settlements established. Their interest in the Far East was as a source of spices especially cloves, pepper, mace and nutmeg. While mace and nutmeg (mace being the fleshy layer surrounding the nutmeg seed) are endemic to several Indonesian islands, they were transplanted around the region including on the island of Penang in the 18th century.

The Portuguese forcibly gained control of Melaka in 1511. The expansionist Dutch took control in 1641 and finally the British took over in 1795 and continued to control the country up until Malaysian independence in 1957 (occupying Japanese forces ruled from July 1941 to September 1945).

AN OVERVIEW OF MALAYSIA

Penang's history is fascinating with Britain becoming interested in the island when much of Asia was still seen as a source of exotic commodities like spices and tea from China. In the late 18th century, Captain Francis Light, an officer with the East India Company, proposed Penang's favourable port-of-call facilities as being suitable for a commercial operation for trans-shipping Chinese tea and other commodities. A lease was negotiated with the Sultan of Kedah and the Union Jack was raised in Penang in 1786 (Penang was initially called Prince of Wales Island).

Light's vision proved correct and Penang quickly eclipsed traffic through the port of Malacca due to its free-trade status. In other parts of the country, natural resources were exploited under British colonial rule with tin mining and rubber

plantations leading the economic development. The British encouraged Chinese and Indian immigrants to settle in Malaya to work the mines and establish agricultural plantations.

In 1824 the East India Company took control of Singapore, which, together with Melaka and Penang, was known as the Straits Settlements by 1826. Singapore's dominance as a trading port increased over time and remains even today.

Other peninsular Malay states eventually came under British influence and British residents were installed to maintain law and order. Malay leaders were encouraged to accept the positions of British Residents to maintain the peace and over time, the rulers signed treaties with the British.

In 1896 the Federated Malay States were formed as a British protectorate headed by a British High Commissioner. This consisted of Pahang, Perak, Negeri Sembilan and Selangor with Kuala Lumpur as the capital. Later on, a treaty with Siam (now Thailand) ceded Kedah, Terengganu and Kelantan. Later Johor joined the fold and by 1919, the peninsula became known as British Malaya.

In December 1941 the Japanese landed in Kota Bharu and the invasion of the peninsula began. There was minimal resistance from the remaining British forces or the locals and within two months all of Malaya (including Borneo) came under Japanese control. The British were rounded up and sent to prison camps in Sandakan in Sabah or to work on the infamous Burma Railway in Thailand, where many thousands died. Many more locals also died with the Chinese being singled out due to antagonism created during the Sino-Japanese War. Some Chinese joined resistance groups such as the Malayan Communist Party and staged a guerrilla war from bases deep in the jungle. At the same time, the Japanese introduced a policy of 'Asia for Asians' to garner support from the Malays and Indians.

After the Second World War, the independence movement in Malaya gained momentum and the Federation of Malaya was formed in 1948 with a constitution that recognized the powers of the sultans in their respective states and gave special status to the Malays as the original occupants of the peninsula. Independence was stalled during the communist uprising known as the Malayan Emergency, which officially ended in 1960. Independence moved closer when the United Malays National Organization (UMNO), Malayan Indian Congress (MIC) and the Malayan Chinese Association (MCA) formed

Above: The statue of Captain Francis Light is located in Penang's Fort Cornwallis.
Opposite: Tanjung Bungah on Penang's northern shores is where many luxury apartment complexes are situated with the main beachside resorts being located nearby at Batu Ferringhi.

an alliance to win the 1955 election (the coalition remains and, along with several East Malaysian parties, is known as Barisan Nasional). The people waited until August 31, 1957 to attain independence from Britain under the first Prime Minister Tunku Abdul Rahman. The day is now known as Merdeka Day and celebrated each year as a national holiday.

Singapore, Sarawak and Sabah joined the federation in September 1963 to complete the Malaysian nation and double the area under its control. This was not well received by the Philippines, who still had its sights on Sabah, or by Indonesia, who controlled the bulk of Borneo and saw the move by Malaysia

AN OVERVIEW OF MALAYSIA

as expansionist. Indonesia launched its *Konfrontasi* against Malaysia between 1963 and 1966 and the situation was quite explosive but localized along the national border in Borneo. Malaysian forces were supported by Commonwealth troops but the situation was eventually diffused and peace prevailed.

To add to the political uncertainty, Singapore parted from the union over ideological differences and became a separate nation and republic in 1965. Differences have been resolved and now Malaysia is one of ten member states of the Association of Southeast Asian Nations (ASEAN) which includes Singapore, the Philippines, Brunei Darussalam, Cambodia, Lao PDR, Myanmar, Thailand, Vietnam and Indonesia.

Above: The National Monument in Kuala Lumpur is a memorial to those Malaysians who died during the Second World War and the Malayan Emergency.

EAST MALAYSIA

Sarawak and Sabah have a different history. While regional trade existed there for centuries, the European colonial powers only became interested in Borneo in the 19th century. In 1841, English adventurer James Brooke was given a large area of present-day Sarawak as his personal fief after helping the Sultan of Brunei suppress an uprising by some local tribes. Brooke succeeded in winning over the locals and set about introducing law and order, uniting the disparate tribal communities of the territory.

Brooke established his base in Kuching and took on the title, Rajah of Sarawak. He and his family successors became known as the 'White Rajahs'. This dynastic monarchy of the Brooke family ruled from 1841 to 1946 until Sarawak was eventually ceded to the United Kingdom. It achieved its independence in 1963.

Northern Borneo (present-day Sabah) became of interest to the British in the mid 19th century. The British North Borneo Chartered Company received a royal charter in 1881 after northern Borneo was ceded by the Sultan of Sulu (based in what is now the southern Philippines). This part of Borneo has been, and still is, disputed by various parties. The British became interested in taking control when other European powers started their regional expansion. With ownership and power being nominal, the sultan was persuaded to lease the land initially to an American and then to Austrian and British interests. Englishman Alfred Dent (a colonial merchant and entrepreneur later to be knighted) obtained the lease from the sultan, then sought a royal charter for northern Borneo.

Kudat in the far north of the state became the capital but this moved to Sandakan in 1883 as the excellent port facilities there enabled the export of timber (its main use even to this day). In 1888, the territory became a protectorate of the United Kingdom but control and administration remained with the company, which effectively ruled until 1942 when the Japanese took control up until 1945.

In 1946 British North Borneo became a British Crown Colony and Jesselton (now Kota Kinabalu) replaced Sandakan as the capital as the latter had been razed to the ground by Allied bombs at the end of the war. The Crown controlled Sabah until 1963 when it joined the Malaysian federation together with Sarawak.

THE PEOPLE

Malaysia's population is 30 million and growing annually at a rate of 2.4 per cent. It comprises Malay (60.3 per cent), Chinese (22.9 per cent) and Indian (7.1 per cent), with the remainder being some 30 other communities many of whom are ethnic groups in Sarawak and Sabah. The Malay, Orang Asli, Malay-related groups (such as the Bugis and Minangkabau) and the original ethnic communities of Sarawak and Sabah are classified by the government as *bumiputra* or 'sons of the soil'. Estimates also suggest there are another three million foreign workers in the country.

It is difficult to categorize the people of the country as there is so much variety in the way the inhabitants lead their lives. Urban Malaysians lead a different lifestyle from those in *kampungs* (villages), there are differences between East Malaysians and West Malaysians and those Malaysians who have been educated overseas often have a different perspective on life from those educated locally. Just as important is that some 70 per cent of the population is urbanized, while 27 per cent of the population is younger than 15 and just 4.7 per cent older than 64.

Ethnic diversity is reflected in the variety of languages spoken in Malaysia. Visitors can sit in a coffeeshop and hear several languages at once or have discussions with locals who might lapse into three languages in the one sentence. Bahasa Malaysia is the official language and the one most Malaysians speak. Malaysians of Chinese heritage will also speak at least one Chinese dialect be it Teochew, Hakka, Foochow, Hokkien, Cantonese or Hainanese. Many Malaysians of Indian descent speak Tamil. When the languages spoken by the Orang Asli and those of the ethnic communities in East Malaysia are included, Malaysia is a country of great linguistic complexity. However, English is widely spoken and understood, especially in urban areas.

The Orang Asli are Malaysia's oldest people who traditionally were nomadic hunters and gatherers of the forests and experts in using poisoned darts fired from blow pipes to kill native prey. While some still maintain this lifestyle, many

This page: Malaysia is a multicultural country mostly comprising Malays, Chinese (below right) and Indians (above right), though there are many other small ethnic groups in Sabah and Sarawak.

more have permanent homes on the fringe of forests where they cultivate cash crops and supplement this with foraging and hunting. There are some communities near Taman Negara and the Cameron Highlands which tourists can visit.

The bulk of Malaysians are Malay, who are defined as people who speak the Malay language, follow Malay customs and believe in Islam. They are more numerous on the peninsula and while the Malay can be taken from the *kampung*, the *kampung* can't be taken from the Malays. Village life is the heart and soul of traditional Malay life as it is a return to a relaxed lifestyle where family values reign supreme. After the fasting month of Ramadan, Malays like to *balik kampung* or go back to the ancestral home to share quality time with their extended family during the Hari Raya holiday.

Known as Hari Raya Puasa, the holiday is celebrated at the end of the Muslim fasting month of Ramadan which falls in the ninth month of the Islamic calendar but whose dates change from year to year. Fasting ends with the sighting of a new moon by religious leaders. During the fasting month, Muslims abstain from drinking and eating between daybreak and sunset to cleanse their soul and to remind themselves of the sufferings of the less fortunate. At sunset, though, the streets come alive with stalls selling all manner of tasty treats with which to break the fast. During the festivities of Hari Raya Puasa that follows, many Malay houses are decorated and colourfully lit. Malays visit the mosque for special prayers and later, the homes of relatives and friends to celebrate. They do this as 'open houses' where all Malay Muslims and visitors are invited to share in the festivities with their Malay friends (the 'open house' concept is common to all other Malaysians when they celebrate too).

The Chinese migrated to Malaya in numbers in the 19th century and in many cases were given help by the various *kongsi* (societies) that were established to assist their fellow countrymen. The Chinese mainly came from coastal regions such as Canton (Guangzhou), Hokkiens from Fujian and Hainanese from the island of Hainan. In the early 19th century, the Hakka people started to arrive. The Chinese were willing migrants who were happy to escape the cycle of poverty back in their homeland. However, when they arrived, conditions were not much better until through 'rags to riches' stories, most became well established.

Some Chinese intermarried with local Malays thus creating the Baba Nyonya or Peranakan culture (Baba being men and Nyonya being women of the intermarriage). Melaka and Penang were the original homes for these people but they now live in many parts of Malaysia. The food that evolved from this union is renowned throughout the land and is considered one of the world's first fusion styles. Several houses in both Melaka and Penang have been restored and can be visited to gain an insight into the lifestyle of these people.

In Melaka a similar union occurred between the Portuguese and locals. Ancestors of the first Portuguese settlers are known as Eurasians. They developed in isolation from Portugal for over five centuries and created another unique community with most members being Roman Catholics. There is a Portuguese settlement just south of Melaka that is popular with tourists who come to dine in restaurants serving Portuguese-styled seafood. Some of the older residents in Melaka's Portuguese settlement still speak Cristao which is an old form of the Portuguese language.

Some Indians came as convicts to help build public infrastructure while others came as free settlers. Other Indians came as soldiers to places such as Penang to protect the port and to supervise the convicts. Many were Bengali and Tamil Muslims and Penang's famous Kapitan Keling Mosque was established by them. Some convicts remained after completing their sentence and were joined by Indian male workers who were brought to Malaya as indentured labour for a set period on a fixed wage. Over time, Indians were brought in to build the railways, roads and to work in plantations such as rubber estates where many still work.

The Chettiars (Chetties or Chitties) of Tamil Nadu descent were a group of Indian migrants who became prominent investors, spice traders and money lenders in the country. Like the Baba Chinese some Indian settlers adopted Malay traits and customs.

Right: The construction in 1801 of Penang's Kapitan Keling Mosque is attributed to Indian Muslim troops from the East India Company. Built in the Indo-Moorish style, it has a single minaret from which calls to prayer are broadcast.

Opposite: The Penang Peranakan Mansion offers a window onto the past life of a rich Baba man.

CHINESE NEW YEAR

Being a nation of several religions, there are many festivals celebrated in the country, some of which are also secular.

Chinese New Year is the most popular of all Chinese festivals and has a long history involving many traditions and rituals. In ancient times most Chinese lived frugally and New Year's Day was one of the few occasions when they could feast and celebrate. It starts well before the New Year as traditionalists close off the current year's business and prepare for the new one. Homes may be decorated with bright blossoming and fruiting plants that symbolize rebirth and new growth while streets and temples are decorated with red lanterns (right). Most Chinese businesses close for at least the first few days of the festival. The first day of the New Year starts with a new moon and ends on the full moon, fifteen days later. The eve and first day are important for family reunions as family, relatives and friends get together for a renewal of the spirit. Chinese like to greet each other with *gong xi fa cai* or 'happy and prosperous New Year'.

A reunion family feast called *weilu* or 'surrounding the stove' symbolizes family unity and honours past and present generations. Dinner treats usually include seafood and dumplings, signifying good luck. Delicacies such as prawns for happiness, raw fish (*yee sang*) to bring good luck and prosperity, and *fai hai* or angel hair (fine seaweed) for prosperity are also consumed.

The first day of the New Year is the time for the ancient custom called *hong bao* or *ang pow*, the giving of red packets containing money to children and single adults. Another tradition, which seems to be more observed by the Chinese in Malaysia than in other countries, is *yee sang*. This revolves around a colourful dish of raw fish where all diners communally toss the ingredients as high as they can with their chopsticks to create good fortune.

Lion and dragon dances are performed in the streets (opposite) to encourage auspicious beginnings such as new businesses or to celebrate the New Year. Young boys concealed inside the lion's costume guide and twist the animal in a simulated lion performance aimed at reaching for a red packet suspended from a high point. Meanwhile a troupe of musicians makes a raucous noise bashing gongs and drums as loudly as they can to drive away evil spirits. There are many other traditions celebrated over the 15-day period.

New Year lasts until the 15th day of the new moon, which is known as Chap Goh Mei or Fifteenth Night. A Lantern Festival is celebrated then with children carrying lanterns at night.

Another Chinese festival is that of the Hungry Ghost which falls on the seventh moon of the lunar calendar, when Chinese believe that the Gates of Purgatory are thrown open and the souls of the dead are released from incarceration to mingle with humans for 30 days. To appease the neglected souls, the Chinese make offerings of food and candles. Incense sticks are lit in rows, sumptuous food offerings are made to pacify the ghosts and in most places, Chinese operas are staged in the streets for all to enjoy.

THE PEOPLE

45

AN OVERVIEW OF MALAYSIA

Below: Intricately-carved burial poles were once used in Sarawak.
Right: This Iban dancer wears a headdress that includes the feathers and casque of a hornbill bird.
Opposite: The Malaysian F1 racing circuit is located near Kuala Lumpur International Airport.

In East Malaysia, there are some 30 different ethnic groups. Distance from the coast affected the way in which these communities came into contact with outsiders and how quickly they changed with the times. The Melanau are a community in Sarawak that lives near the coast and was first influenced by outsiders. Ibans, the largest ethnic group in Sarawak, are an inland river people who adorn their bodies with intricate tattoos and are best known as being headhunters in days gone by. Now many have converted to Christianity and lead peaceful lives. Traditional Ibans still live in longhouses, which are elongated houses where the individual families have a close relationship. Each family has its own private quarters behind closed doors while sharing one long communal space along a covered and enclosed veranda. Their longhouses front a river and the cooking is mostly done by the women using wood for fuel.

Bidayuh (formerly Land Dayaks) are the second largest community in Sarawak who also traditionally lived in longhouses, though the chief's hut or *rumah pangah* is different in that it is circular and made from bamboo with a conical-shaped, *attap* roof. Overhanging eves keep rain out and the interior cool, while an adjustable flap in the roof allows light in as required. Bidayuh people were once animists who believed in ancestor worship but now many have converted to Christianity.

The Kenyah and Kayan people live inland, distinguished by a once-traditional common practice where they used to stretch their earlobes, as well as by their intricately woven hats.

Sabah's main ethnic peoples are the Kadazan-Dusun (or Kadazandusun) with some 40 ethnic sub-groups including the Murut, Rungus and the Orang Sungai (or River People). Many once lived in longhouses and were animists with harvesting

rituals being central to their beliefs. They comprise one third of the 3.2 million people who live in Sabah with many of them having converted to Christianity. Visitors to Sabah can learn more about these people by visiting the House of Skulls at the Monsopiad Cultural Village in Penampang on the outskirts of Kota Kinabalu.

Malaysians living in both the peninsula and Borneo are friendly people who openly welcome tourists to the country. They love to share the nation's wonderful food with visitors and take great delight when tourists sample exotic food such as durian and *petai,* and any number of dishes for which Malaysia is famous (see pages 50 to 55).

In their spare time Malaysians love to shop, visit markets, rest, eat and participate in some form of recreational activity. Malaysians love their sport and include amongst their ranks several world champions in the sports of badminton, diving, lawn bowls and squash. The sport which most watch is football (soccer) and while national and state teams are well supported, matches from all the leading international competitions are the ones followed on television.

In 1998, Kuala Lumpur hosted the Commonwealth Games and many new sporting facilities were built. Malaysia's tropical heat ensures that many Malaysians enjoy indoor sports like badminton, squash, ten-pin bowling and basketball. Other sports played include tennis, hockey, golf, football, swimming, cycling, rugby, triathlon, diving and lawn bowls. Local sports such as *sepak takraw* (a kind of volleyball played with the feet), *silat* (a form of self defence), kite flying and top spinning are still enjoyed in some parts of the country.

Malaysia's most prestigious sporting event, attracting motoring fans from around the globe, is the Petronas Malaysia F1 Grand Prix staged annually at the purpose-built Sepang International Circuit located near Kuala Lumpur International Airport (KLIA).

RELIGION

Malaysia is a multi-denominational country with the main religions being Islam, Buddhism, Hinduism, Taoism, Christianity, Confucianism and Sikhism. Islam is practised by more Malaysians than any other religion. In some parts of Malaysia such as Jalan Tokong (Temple Street) in Melaka, various places of worship co-exist close to each other. Here, Kampung Kling Mosque, Sri Poyyatha Vinayagar Moorhi Hindu Temple and the Anglican Christ Church are all near one another.

ISLAM

Evidence suggests that maritime traders introduced Islam in the 7th century and that it was well established in the country by the 14th century. It has been the mainstay of Malay life since then. These traders came from Arabia, India and China with those from India having a major influence. Kedah was the first state to be influenced from where Islam slowly spread to coastal ports in other parts of the country and neighbouring islands such as Sumatra.

Malaysia is a secular state with Islam being the official religion and the King being the defender of the faith. Malay sultans maintain authority over religious affairs in their respective states while the King plays this role in Penang, Melaka, Sarawak and Sabah where there is no sultan.

The call to prayer five times a day can be heard around the country with Friday lunch-time prayers being the most significant. Many government departments have an extended lunch break on Friday so that devotees can attend the mosque to pray; Malaysians of all faiths enjoy the extended break too. The states of Kelantan, Terengganu, Kedah and Johor take their weekend breaks on Friday and Saturday with Sunday being a working day. In all other states and federal territories the weekend is considered to be Saturday and Sunday. Sharia courts preside over legal matters mostly related to Muslim families and some Malay women choose to wear a *tudung* or headscarf.

BUDDHISM AND TAOISM

Most Chinese temples in Malaysia had humble beginnings as shrines but are now rather ornate temples dedicated to Buddhist and Taoist deities. Simple shrines still exist with the 'kitchen god' outside houses or shops being the god that protects the hearth and the family. Food and incense sticks are offered at the shrine. Simple roadside shines to Na Tuk Kong (a local guardian spirit that lives in trees) can be seen, often with Chinese praying there or making offerings of betel nut, tobacco or oranges. Some temples are grand and colourful buildings while others, such as Datuk Kong Temple, retained within the grounds of Temple Tree Resort Langkawi, are very simple. Elaborate rooflines and

RELIGION

Left: The Burmese Buddhist Temple in Penang is busiest during Wesak Day and Thankyan (the Water Festival).
Below: The Thai Buddhist temple is opposite the Burmese temple in Penang.
Opposite left: The Sultan Salahuddin Abdul Aziz Mosque in Shah Alam, Selangor, is the largest in Malaysia.
Opposite right: Tua Pek Khong Chinese Temple is said to have the best *feng shui* location in Kuching, Sarawak.

lintels are typical with many designed along the lines of *feng shui* and decorated with mythical characters to ward off evil forces.

Buddhists observe Wesak (or Vesak) Day in early May as the auspicious day on which to celebrate the birth, enlightenment and passing of Lord Buddha. Most Buddhists light candles and pray at Buddhist temples around the country or join in the colourful procession through the streets of George Town, Penang. Some devotees consume only vegetarian food on Wesak Day as part of their vow. An interesting feature of the day is the releasing of caged birds as a symbol of kindness to all living creatures.

Several Buddhist temples in the country have an affinity with neighbouring countries such as Thailand and Myanmar. In Penang, the Dhammikarama Burmese Buddhist Temple is located opposite Wat Chayamangkalaram Thai Buddhist Temple. Wat Phothikyan near Bachok in Kelantan is an example of a Sino-Thai Buddhist temple.

HINDUISM

Hinduism has been introduced to Malaysia over the centuries by Indian merchants. Indians arrived in the country via Melaka in the 15th and 16th centuries and established temples. Some 80 per cent of Indian immigrants are Hindus of South Indian descent. Many of the 2,000 Hindu temples in the country are characterized by an open design with highly intricate statues painted in very bright colours. Two popular Hindu places of worship are the Sri Mahamariamman Temple in Kuala Lumpur's Chinatown and the temple and shrine in the Batu Caves on the outskirts of the capital.

Deepavali or the Festival of Lights is another auspicious Hindu festival that acknowledges the triumph of good over evil, wisdom over ignorance and light over darkness. Steeped in mythology, one of the two legends related to the origin of Deepavali tells of the victory of Lord Krishna over the demon King Narakasura. To celebrate Lord Krishna's victory, Hindus decorate their homes with tiny oil lamps and open houses are held when friends are invited for food, drinks and celebration.

RELIGION

THAIPUSAM

The festival of Thaipusam is important to Hindus especially in Malaysia and Singapore (it is banned in India because it can involve harming the body). It is celebrated on the full moon in the Tamil month of *Thai* (January/Feburary) and lasts for several days, during which offerings are made to Lord Murugan, a Hindu deity. This is definitely one of the world's most garish religious celebrations as devotees pierce their bodies and carry heavy weights (*kavadis*) to seek penance for their sins. In Kuala Lumpur the festival attracts over one million Hindus and observers. It starts with a chariot procession that departs from Sri Mahamariamman Temple in Chinatown for the 15-km (9-mile) journey to Batu Caves, where devotees climb the 272 steps to the top.

First celebrated at the caves in 1891, today it is as much a tourist event as a religious festival with a colourful carnival atmosphere. Despite the seething mass of humanity, it is something to witness. Penang attracts the second biggest gathering for the pilgrimage to Arulmigu Balathandayuthapani Temple located 500 steps above Waterfall Road. There are large numbers for the event in Ipoh and Johor as well.

CHRISTIANITY

Some nine per cent of Malaysians are Christians of several denominations including Roman Catholics and Protestants, most of whom live in East Malaysia. Christianity is considered to have been brought to the country by the Portuguese who arrived in Melaka in 1511. Foreign missionaries also came to Malaysia to covert the locals. There are numerous Christian churches in the country with St Mary's Anglican Cathedral and St Andrew's Presbyterian Cathedral in Kuala Lumpur being two of the largest.

Christmas Day marks the birth of Christ and is celebrated by Malaysian Christians in the spirit of goodwill with the call of peace and good fellowship. The festive mood during the month of December culminates on Christmas Eve. Congregations pack churches to attend mass and other services while nightspots celebrate with festivities as seen in many other parts of the world.

Above: Originally a Dutch Reformed Church, Melaka's Christ Church was re-consecrated in 1838 as a Church of England place of worship.

Opposite top: Temple Cave is the largest at Batu Caves and has been used for worship by Hindus since 1890.

Opposite below: This Hindu temple in Kuala Lumpur's Chinatown is another example of Malaysia's multiculturalism.

AN OVERVIEW OF MALAYSIA

CUISINE

LIVE TO EAT

Malaysians live to eat and with so much variety, visitors to Malaysia soon appreciate why the locals talk more about food than anything else. *Sudah makan* (have you eaten?) is a common greeting followed by a drink or snack often consumed in a local coffeeshop (*kopitiam*).

Malaysians of all social levels sit together in a *kopitiam* to enjoy snacks and a drink. The national beverage *teh tarik* (stretched tea) is made by passing tea from one container to another to create a frothy head. Coffee is also popular. Previously coffee beans were roasted (mostly with margarine) on the premises but most now buy in pre-roasted beans. Ordering in a coffeeshop can be a minefield as there are many variations on the theme. Condensed milk rather than fresh milk is commonly used. Local *kopitiams* are important for socializing but coffee and tea aren't the only drinks sold as barley water, soy bean drinks and juices are also available. Often the owner will sell beverages and a few food items but will lease out space to other food sellers. In really busy coffeeshops, some half-a-dozen vendors will sell cooked food but usually each one produces only one or two dishes in which they specialize.

Malaysians are proud of the incredible range of dining delights and are happy to introduce visitors to their many famous dishes. Malay, Chinese and Indian cuisines combine to make up what foreigners know as Malaysian food. However, there is a wide diversity across the country with different styles of well-known Malay dishes being found in the various states, as well as a multitude of regional Chinese cuisines and a wide variety of Indian foods.

It's not only the food that is unique but also where and how it's eaten that is just as fascinating. This ranges from makeshift seating at simple roadside stalls, to evening meals in the open air

under the stars, on the sands of tropical islands or in some of Asia's finest restaurants. Most outlets are family-friendly and eating out as a family is popular, especially at weekends. Malaysia's hawker or street food is considered some of the best in the world and is much loved by all Malaysians. Numerous *nasi kandar* stalls and restaurants serving a smorgasbord of rice plus vegetable and meat dishes are located in Malaysia (see also page 54). Some Malaysians eat with their hands, using the right hand only.

Malaysians like to snack regularly and dish sizes aren't large. *Kueh* (cakes), *pisang goring* (fried bananas) and Indian *vadai* (fried *dahl* cakes) are popular snacks to enjoy between meals. Some stalls only open at certain times of the day when the dish they cook is most popular and several stalls may be located inside a coffeeshop. Others may be temporary 'pop up' stalls with a few plastic chairs for patrons.

Rice (*nasi*) is the staple food and eaten by all people but with lots of variations on the main form of plain steamed rice. *Nasi kerabu* (blue rice) is a speciality in Kelantan and Terengganu, where it is a variation of *nasi ulum* (cold steamed rice topped with herbs, spices and vegetables). The rice gets its colour from being cooked with the blue petals of the Butterfly Pea flower. It is eaten with fried chicken or dried fish accompanied by crunchy prawn crackers. *Nasi lemak* is a popular breakfast dish of rice cooked in coconut milk and served (often wrapped in a banana leaf) with *ikan bilis* (tiny dried anchovies), hard-boiled eggs, cucumber and a spicy *sambal* (chilli sauce).

Markets are where fresh produce is sold mostly on a daily basis. Being surrounded by water, there's an abundance of fresh fish, prawns and other seafood. Malaysia is also home to many varieties of fruit including starfruit, mangosteens, pineapples, papayas, watermelons, durians, jackfruit, rambutans, cikus, mangoes, chempudaks, dragonfruit, bananas, rose apples, sour sop, pomelos, longans and lychees. Temperate fruits such as strawberries are grown in the Cameron Highlands and many other imported fruits are sold in the markets.

Left: Malay cakes or *kueh* are a popular snack.
Top: A group of hungry young women selecting food at an open-air stall.
Opposite: The term 'coffeeshop' is used to refer to a place where several stalls offer hawker food, while drinks such as coffee are provided by the shop owner.

KING OF FRUIT

No other fruit generates the controversy that durian does – it's either deep admiration or intense dislike for this smelly, spiky and over-sized Southeast Asian fruit. Durian is known as the king of fruits (mangosteen being the queen) and several varieties grow naturally in Malaysia. The island of Borneo is its biological home and here the flesh colour ranges from yellow to red. While there are some 30 species, just ten are eaten but there are hundreds of cultivars now grown in many tropical parts of countries from Australia to Vietnam. Most list the 'D24' variety as being the pick of the crop (the smelliest of them all). The most common varieties grow to the size of a rugby football. The outer husk is a thick woody material covered in thorny spikes that requires a machete or axe to open it. It measures from 15 cm (six inches) to 30 cm (one foot) and weighs in at around 3 kg (6½ lb). However, when they come into season, durian lovers travel for miles to savour the fleshy, custard-like interior, which is high in protein, fibre, calories, and vitamins A and C. During the seasons from June to July and November to December, roadside stalls, supermarket displays and restaurant promotions are common throughout Malaysia and the region. Foreigners will endear themselves to their Malaysian hosts by pronouncing that Malaysian durians are better than those from neighbouring Thailand.

Durian lovers have their own unique way of identifying a ripe and tasty fruit and it is not unusual to see people at stalls, shaking, smelling and poking the thorny fruit. Once selected, the stall owner cleaves the husk apart for an even closer inspection until the preferred flesh is finally identified.

Noted English novelist and one-time resident of Malaysia, Anthony Burgess wrote in one of his first novels, *Time for a Tiger* that durian was: 'Like eating a sweet raspberry blancmange in a lavatory'. However, those who love durian will tell you it is the taste, the texture and the fact that it is seasonal that make it so keenly sought after.

Pasar malam (night markets) are one way to experience a typically Malaysian evening, and each city and town has its late afternoon to evening market in set locations on specific nights. Hawkers and traders establish their makeshift stalls at sunset to sell fresh fruit, vegetables, meats and freshly-cooked snacks to eat in the market or for take-home consumption. Stallholders set up and usually offer just one or perhaps a few dishes prepared at home, then add the finishing touches in the market. Hawker stall food is the ultimate in specialization with some being family businesses that extend back several generations. Many people buy raw ingredients to cook at home or purchase ready-to-eat meals with *satay* (chicken or beef) being a favourite.

Malay dishes are spicy with chilli, garlic, onions, lemongrass, ginger and *belacan* (shrimp paste) being essential ingredients in many recipes. Beef, chicken and seafood provide an invaluable source of protein, usually served with rice. Beef *rendang* is a Malay dish prepared with cubes of beef which are cooked in rich, spicy coconut cream gravy. Most dishes are spicy hot but not all. Malay food is also *halal* (pork-free and prepared according to Islamic laws) and unaccompanied by alcohol.

CUISINE

Left: Many Malaysians buy food at a *pasar malam* or night market.
Below: Fried rice or *nasi goreng* is a popular dish and in this case has been served with chicken satay and *keropok* (deep fried crackers).
Bottom left: Certain beef ball noodle dishes have attained a cult following amongst discerning diners.
Bottom right: Dim sum snacks are especially popular with the Chinese community in Malaysia.

Chinese food introduced by the Hokkiens and the Cantonese encompasses many well-known dishes. These include *char kway teow* (a wok-fried dish of noodles flavoured with soy sauce, chilli, prawns, cockles, bean sprouts, egg and *belacan*) and *kway teow soup* (flat rice noodles, chicken, prawns, bean sprouts and spring onions in a chicken broth). Hainanese chicken rice, fried rice, *dim sum* (bite-sized steamed or fried delicacies) and Hokkien *mee* (wok-fried noodles) are just some of the many other Chinese specialities. Seafood such as fried garoupa, buttered prawns and oyster omelette are cooked Chinese-style in many parts of Malaysia.

55

AN OVERVIEW OF MALAYSIA

Indian food is served across Malaysia but mostly on the peninsula where the majority of Indians live. Spicy curries are the standard fare but with support from many other dishes, such as *nasi biryani,* which is a rice dish prepared with spices and ghee. Many Indians are Hindu and therefore don't eat beef but chicken, vegetables and seafood are plentiful. Rice is popular in South Indian dishes such as banana leaf curry (rice, vegetables and meat served on a leaf) while breads such as *naan* are more common in North Indian cuisine. Spicy *tandoori* chicken prepared in a clay oven, fish head curry and *thosai* (rice and lentil flour pancake) are other Indian dishes to seek out. Indian snack food, mainly fritters such as *pakoras, vada* and *samosas,* is sold for consumption between meals over a cup of tea or coffee.

Indian and Mamak (Indian-Muslim) dishes are keenly sought-after throughout the country with the most famous being *nasi kandar* (steamed rice accompanied by curries and other dishes). Penang is considered to have Malaysia's best and the locals will argue over the merits of various famous stalls on the island. Once peddled around the streets with containers of food suspended over a *kandar* (pole), *nasi kandar* is now sold in stalls and coffeeshops throughout Penang. Another popular dish is *rojak*, which simply means mixed, and there are two main versions: one with fruit and one that is savoury. The savoury version includes bean curd, boiled potatoes, bean sprouts, prawn fritters, hard-boiled egg and cucumber with liberal lashings of a spicy peanut sauce.

Many locals enjoy *roti canai* or *roti jala* especially for breakfast. Both are wheat flour-based breads but are made differently. *Roti canai* is an Indian-inspired, circular flat bread made with oil, margarine or ghee and kneaded, flattened and oiled before being twirled in the air much like an Italian pizza. It is then fried until it is soft and flaky. There are many variations from savoury to sweet with the former being mostly served with dhal or curries. *Roti telur* (with an egg) is the most common variation. *Roti jala* is made from a liquid batter poured onto a skillet from a container with holes in the base. The resultant lace-like bread is served with the same accompaniments as *roti canai*.

While various Asian countries argue over the origins of *satay* few deny its universal appeal. Small morsels of chicken and beef marinated in turmeric, coriander and lemongrass are threaded with shallots onto bamboo sticks and barbecued over sizzling charcoal, then served with onions, cucumber, a spicy peanut sauce and occasionally, cubes of rice.

Malaysians were possibly the first to experiment with fusion cuisine long before it became fashionable. When Chinese males (Baba) married local Malay wives (Nyonya), Nyonya or Peranakan cuisine transpired. Over time, Chinese ingredients were blended with Malaysian spices to create the distinctive style. *Asam laksa* is one of the most noted Penang Nyonya dishes, known for its sour flavour. Short rice noodles form the basis of the dish to which a spicy, fish-based broth flavoured with ginger flower, *belacan*, chilli, turmeric and lemongrass is added. Tamarind provides a degree of tartness and the dish is served in a bowl and topped with grated cucumber, pineapple, onions, ginger flower, mint and chillies.

Beer maybe sold in Chinese and Indian coffeeshops but never in a Malay or Mamak coffeeshop. International hotels and restaurants, especially in cities and resort destinations, offer a comprehensive range of wines and other alcoholic beverages. International cuisines and fusion restaurants are also found in the larger cities and towns.

Above: Nyonya seafood is prepared from a fusion of Chinese and Malay ingredients.

Top left: The smell of sizzling *satay* over blazing charcoal is almost as enticing as the taste.

Top right: *Asam laksa* is a sour fish soup with rice noodles served in a tamarind-rich gravy.

Opposite: Many Indian restaurants offer snacks to sustain hungry patrons between bigger meals.

ARTS AND CRAFTS

Artisans were an important part of life in the royal courts of the land and the rulers fostered crafts, such as carving and weaving, and trades, such as silversmithing and goldsmithing.

Batik textiles have been designed and made in Malaysia for centuries. They feature a distinctive design made by using hot wax as a dye resist to outline motifs through repeated dyeings, resulting in a complex palette of colours. Traditionally the design is created using a wax pencil but patterned blocks are also used. Malaysian *batik* tends to be brighter than that from Indonesia with most of the *batik* on sale in Malaysia originating from its neighbour. The Batik Museum is Armenian Street, Penang is a good source of information about the textile.

Songket is a woven silk brocade incorporating silver and gold threads. It was especially popular with East Coast royalty as it was expensive. The motifs and colour of the *songket* revealed the status and position of the wearer. It is still made, though mostly with synthetic thread, and is highly prized for clothing to be worn on important occasions.

Below left: *Batik* designs are traditionally made using a container (*canting*) of hot wax to outline motifs, which are then resistant to the subsequent dyeing.
Bottom left: Designs on traditional *batik* cloth can also be made using carved wooden blocks.
Below right: Many forms of contemporary *batik* cloths have patterns that are skilfully painted onto silk or cotton.

ARTS AND CRAFTS

Handicraft centres are common in various parts of the country (Kuala Lumpur, Langkawi and Kota Bharu, for example). These sell local handicrafts such as woven baskets, textiles, wood carvings, *wau* (kites) and pewter items. With its abundant tin reserves, pewter (an alloy of tin, copper and antimony) products have been made in Malaysia since 1885 when Royal Selangor Pewter was established. Its items are now sold throughout Malaysia and globally, and there are two showrooms where visitors can learn more. Located in KL's suburban Setapak Jaya and Straits Quay in Penang, visitors can also make their own pewter bowl at the 'School of Hard Knocks'.

Above left: Sarawak is home to woven cloth called *ikat* and intricately-carved wooden products.
Above right: Traditional kite flying using a *wau* is still mostly practised on the East Coast of the peninsula.
Right: Malaysia has a strong tradition of basketry using natural materials with modern forms now using richly-coloured artificial materials.

AN OVERVIEW OF MALAYSIA

East Malaysia is known for different textiles, such as *pua kumba* – cotton blankets woven on a back-strap loom, for which the warp threads are tie-dyed and the weft threads used to create intricate motifs. It is a traditional Iban craft form mostly practised by women. The motifs and colouring were usually inspired by the environment and patterns would be passed down from mother to daughter.

Many tribal people in East Malaysia have tattoos and tattoo artists still ply their craft but now use modern equipment rather than hand-tapped utensils. Colourful beads were once considered currency in Borneo and are still used to make jewellery and to be stitched into items of clothing. Seeds and fern stems that were once a source for beadwork have been replaced by ceramic beads.

Above: In Sarawak, Ibans weave *ikat* cloth to make *pua kumba* blankets.
Right: Many East Malaysian communities continue basketmaking and beadwork traditions.
Opposite: Contemporary art and traditional wood carvings are a feature of the National Art Gallery.

ARTS AND CRAFTS

There are several public and private art galleries in the country with the National Art Gallery in Kuala Lumpur being the focus for Malaysian art. The nation's first art gallery was located in a disused corner of the old Parliament House and then relocated to the former Majestic Hotel opposite the Kuala Lumpur Railway Station. In 2000, the new purpose-built National Art Gallery opened near Lake Titiwangsa. Its design alludes to the *songket tengkolok* or national headdress and is also home to the National Theatre. Galeri Petronas in the Petronas Twin Towers displays art sourced locally and internationally.

There are several distinctive performing arts in Malaysia. Drums form an essential component of the music played by most communities in Malaysia especially the Malays, Indians and Chinese. The giant drum called *rebana ubi* was once used to communicate between isolated communities. Drums, gongs and cymbals are used by musicians who accompany dragon dance troupes. The *gamelan* is a traditional orchestra that has its roots in Indonesia and has been adopted in parts of Malaysia. It is a musical ensemble of metal percussion instruments with the dominant sound made by bronze gongs of different pitches being hit with small hammers.

Wayang kulit is a traditional form of shadow puppetry involving two-dimensional puppets being backlit onto a screen. This type of puppetry is also found in Indonesia and Thailand and has long been used to entertain audiences, to provide social commentary and as a way of teaching morals. It originates in the Hindu culture where it is based upon the *Ramayana* epic. It has been adopted in parts of Malaysia by the Malay people but has been a controversial topic in recent years through being banned in certain states because of its non-Islamic roots.

Below left: *Wayang kulit* (shadow puppetry) is featured in this Langkawi museum.

Below right: Drums are important in all three main communities in Malaysia.

Opposite: Brass kettle gongs are an essential instrument in the Malay *gamelan* orchestra.

ARTS AND CRAFTS

CHAPTER II

KUALA LUMPUR *and* SURROUNDS

A Union of the Past and Present

Kuala Lumpur (mostly shortened to 'KL') developed in 1857 as a mining camp when tin was discovered by a group of Chinese prospectors on the spot where the ornate Jamek Mosque (Masjid Jamek) now stands near Chinatown. Here the Klang and Gombak Rivers meet; the name Kuala Lumpur ingloriously means 'muddy estuary'.

Left: The Petronas Twin Towers and their connecting skybridge are an impressive icon of Kuala Lumpur. They are visible from all over the city, and dominate the night sky. The surrounding gardens belong to the Kuala Lumpur City Centre (KLCC).

Life for the miners was tough from the start and not made any easier by the site's poor sanitation, prevalent disease (malaria) and isolation. It was also quite lawless initially until the miners were brought under control and infrastructure was slowly put in place. The Sultan of Selangor appointed a 'Kapitan China' to maintain law and order. The first one was Yap Ah Loy who was in control from 1868 to 1885 and he apparently did a good job with the aid of just six policemen.

In 1879 Kuala Lumpur became the Selangor capital after it was relocated from Klang 35 km (22 miles) downstream and on the Straits of Malacca coast. By then its population was 5,500 and by 1886 it was linked by rail line to the former capital.

It slowly developed and much of the colonial building programme was initiated in the 1880s under the guidance of Selangor's first British resident, Sir Frank Swettenham, when Malaysia was still the British colony known as Malaya. Many visitors are impressed that the city is now cosmopolitan but still retains some of its early buildings especially those grand colonial ones. It's a city of contrasts: futuristic skyscrapers rise above stately heritage buildings which resemble Indian palaces. Young hipsters sip their preferred shot of caffeine while their grandparents sit next door in a traditional coffeeshop slurping local *kopi* as they have done for decades.

KL is Malaysia's biggest city with some four million residents as well as being the gateway airport for most inbound travellers. Visitors arriving at the state-of-the-art Kuala Lumpur International Airport (KLIA) or Terminal 2 (for low-cost carriers) will get their first favourable impression of the capital here. Built in 1998 and serving both international and domestic routes, the $US3.5 billion terminal has won awards for being one of the world's best airports. Over 50 international carriers fly into KLIA with the national carrier, Malaysia Airlines, providing connectivity to the rest of the world. Not only is KLIA the gateway for KL but it's also the main entry point for most international arrivals.

The KLIA Ekspres train provides the fastest connection from KLIA to the city transport hub at KL Sentral. From here, various trains operated by Keretapi Tanah Melayu (KTM) connect to suburban destinations such as Klang and Rawang as well as international destinations like Thailand and Singapore. Taxis and buses also depart from the hub and the Putra Light Rail plus KL Monorail operate to destinations throughout the city.

Opposite: The Art Nouveau Queen Victoria Fountain stands in Merdeka (Independence) Square and is surrounded by a collection of disparate architectural styles, including the contemporary Dayabumi Complex, typical of the mix in Kuala Lumpur.
Below: The Mogul architecture of the late 19th-century Sultan Abdul Samad Building housing government offices contrasts with the ultra modern Petronas Twin Towers in the background.

While KL Sentral is now the main rail hub, the original station is one of the city's landmark colonial buildings. It still operates as a railway station. Suburban trains stop here as does the luxurious Eastern & Oriental Express on its journey from Singapore to Bangkok. The station building was designed by British architect A.B. Hubback and completed in 1910. Its ornately detailed structure is typical of the Indian Mogul (often called Moorish) architectural style with features such as the elegant *chhatris* (dome-capped pavilions). The Railway Administration Building opposite is in the same style but wasn't

completed until after the Second World War. The station once incorporated a hotel but this no longer operates. Travellers seeking an experience dating back to the golden age of railway travel can book into the renovated Majestic Hotel, which is located opposite the station.

Dataran Merdeka (Merdeka Square) centred on the *padang* (playing field) is where Malaysia gained its independence in 1957. It is also where the British once played cricket watched by spectators sitting in the members-only, Tudor-styled Royal Selangor Club dating back to 1895. Interestingly, the Hash House Harriers (the 'running group with a drinking problem') started here in 1938 and now has 2,000 chapters all around the world including Antarctica. Most of the grand buildings around the *padang* are of Mogul style, similar to the old railway station, the most stately of which is the Sultan Abdul Samed Building with its glistening copper domes, ochre-coloured masonry and white-arched colonnades. Built between 1894 and 1897 it originally housed the offices of the Federated Malay States.

One of the best times to admire the building's beauty is in the evening when it is illuminated by thousands of fairy lights.

Masjid Jamek is the city's oldest surviving mosque and sits serenely at the confluence of the Gombak and Klang Rivers. The mosque was also designed by Hubback and is one of the city's most photographed buildings.

The KL skyline is now dominated by taller glass and steel buildings that have only emerged over the past few decades. One of the city's most elegant buildings of recent times forms a backdrop to the Sultan Abdul Samed Building. The 35-storey Dayabumi Complex was built in the 1980s on a 12-point, star-shaped plan with modern Islamic styling featuring lattice grills on the exterior.

Above: While Kuala Lumpur city centre reaches ever skywards, there are still many leafy areas including a small forest reserve surrounded by skyscrapers and the Royal Selangor Golf Club just minutes away from the towering Petronas Twin Towers.

KL is a city on the move; there is a vision that the capital and the nation will attain developed economic status, and infrastructure is being put in place to enable this to happen. Construction cranes punctuate the skyline as new buildings reach ever skywards and 'men at work' signs are everywhere in the city centre. Its streets are already jammed at rush hour and it's common to hear KL-ites refer to 'the jam' as an all-encompassing term to explain many things from being late for work or an appointment to not turning up to a function.

Like many cities in emerging Asia, KL rarely slows down and even in the early hours of the morning, some coffeeshops and cafés remain open to cater to shift workers, late night revellers and football fans huddled around a television monitor watching English League football.

Visitors can enjoy the thrill of modern KL or retreat to some peaceful parks and lakes in and around a city of gardens. Other parts of the city reflect the nation's multiculturalism from Malay hawker stalls to Indian curry houses and Chinese temples. Integrated hotel-shopping-entertainment complexes in the city provide one-stop destinations where visitors can check into a hotel, shop, dine and be entertained before checking out never having left the confines of the air-conditioning. Visitors can also enjoy the total sensory experience of the city by walking its footpaths to discover just how unique KL really is.

Less than two decades ago, downtown Kuala Lumpur was centred on a horse-racing track. As the needs of the city grew, the track was relocated to enable one of the world's greatest inner city redevelopments ever undertaken in the heart of a city. This became the Kuala Lumpur City Centre (KLCC). KLCC is dominated by the two 88-storey structures of the Petronas Twin Towers, which symbolize Malaysia's national aspirations. The $US2 billion towers are the headquarters for the country's national oil company, Petronas. From 1998 to 2004, the towers reigned as the world's tallest buildings and though they have been superseded by others, they still remain the world's tallest twin towers. Being Malaysia's 'must-see' building, they attract many sightseers. While it's not possible to go to the very top, there is public access to levels 42 and 86 to admire skyline views.

The KLCC precinct also contains a Convention Centre and Suria KLCC, one of the city's most prestigious shopping areas, along with restaurants and bars. The base of the Twin Towers houses a stunning, timber-lined auditorium; a world-class performance space that hosts many leading artistes and is home to the Dewan Filharmonik Petronas and the Malaysian Philharmonic Orchestra.

The state-of-the-art interactive Petroleum Discovery Centre (Petrosains) is also situated here. Ideally located in the shopping hub of Suria KLCC, the interactive displays highlight the importance of petroleum to the Malaysian economy. There are scores of exhibits designed to educate, arouse and stimulate young minds. Various activities such as a simulated helicopter ride introduce some fun elements and there is a shop retailing educational games and souvenirs.

Aquaria, located beneath the Convention Centre, provides an opportunity for visitors to observe sharks and other marine creatures. One of the most exhilarating experiences is to walk through a glass tunnel with sharks and giant rays swimming overhead. Other exhibits offer an insight into tropical rainforests, mangroves and coral reefs.

Extensive gardens, a jogging track, shaded areas, playgrounds and ponds surround the towers providing recreational space in the heart of the city.

The capital has several famous streets which are now tourist destinations. Jalan Alor is one of KL's best known food streets although, during the day, the activity is reasonably subdued. At dusk, traders wheel their barrows onto the footpath and the street becomes a hive of activity. It doesn't take long for the narrow street to become crowded as motorists double-park to buy snacks from their favourite stalls. Throughout the evening, diners can sample a whole range of dishes served from numerous stalls. Changkat Bukit Bintang or 'pub street' is one of the liveliest restaurant and pub precincts in the inner city and is within walking distance of Jalan Alor.

Petaling Street and the adjoining streets in Chinatown pulsate all day long with lively banter and bartering for shoes, clothing, watches, jewellery and souvenirs that reach a crescendo in the evening. While many branded items are not the real deal, it doesn't stop the happy throngs of shoppers nor those who come to eat here.

Opposite: Three large towers dominate Kuala Lumpur's Central Business District with Menara Kuala Lumpur (left) at 420 m (1,379 ft) and the Petronas Twin Towers at 451 m (1,480 ft).

KUALA LUMPUR AND SURROUNDS

Above: Malaysians love to eat at hawker stalls, like those in the popular food street of Jalan Alor in Kuala Lumpur.
Left: Petaling Street in Chinatown is a must-visit shopping and eating street.
Opposite page: Lake Gardens is a multiple-purpose green lung with trails, orchid gardens, lakes and various recreational activities.

Despite the rapid urban growth, there are still several substantial open spaces that serve as recreational areas for city residents. The largest is the 104-ha (257-acre) Perdana Botanical Gardens or Lake Gardens where century-old rain trees provide shelter from the sun's intensity. While there are many fascinating plant specimens, the jogging tracks and playground equipment ensure that the park is equally as important for recreation. There are several tourist attractions around the gardens including a bird park featuring enormous walk-through aviaries, an orchid garden, a butterfly park and a deer park. The Asean Sculpture Park, National Monument and National Museum are on the perimeter, while the former official residence of the British High Commissioner – now the Carcosa

KUALA LUMPUR AND SURROUNDS

Seri Negara boutique heritage hotel — is within the parkland area. The Queen of England once stayed in the stately Carcosa with its handful of suites, restaurant showcasing contemporary Malay cuisine and shaded veranda on which English afternoon teas are served.

There are several other recreational areas in and around Kuala Lumpur. The Forest Research Institute Malaysia (FRIM) in suburban Kepong is a mixed-use forest site with several trails, streams, picnic areas and a canopy walk. Adventurous visitors can head further into the suburbs to explore other forest trails, such as Bukit Gasing (Petaling Jaya), Bukit Kiara (Taman Tun Dr. Ismail) and Taman Botani Negara (Shah Alam).

Left: The Asean Sculpture Park in Lake Gardens can be combined with a visit to the National Monument.
Below: The National Monument is a solemn memorial to Malaysians who sacrificed their lives during wartime.
Opposite: Opened in 1963, the National Museum combines traditional Malay architecture with modern building design.

On the other side of town, Lake Titiwangsa is a large park formed around a tranquil lake that attracts joggers, picnickers and canoeists.

KL is the only world capital to have a stand of primary rainforest within its city centre. Bukit Nanas Forest Reserve covering 9 ha (22 acres) is located at the base of the 421 m (1,381 ft) high Menara Kuala Lumpur (a telecommunications tower). There are several well-signposted trails and an interpretation centre detailing many features of the lowland dipterocarp forest. One of the most accessible aerial views of the whole city is from the tower where there is an observation desk and revolving restaurant near the summit.

Shopping centres keep being built in the city and the suburbs as most Malaysians would probably list going to a shopping mall as their number one recreational activity. The country's tropical heat encourages activities in air-conditioned interiors and mall planners recognize this by providing a variety of activities within enclosed spaces to ensure they become one-stop, family entertainment centres. Popular shopping malls in the city centre are Pavilion KL, Lot 10, Starhill Gallery, Fahrenheit 88, Low Yat Plaza, Berjaya Times Square, Sungei Wang and BB Plaza. In the suburbs, shoppers throng to Mid Valley Megamall and Gardens, 1Utama, Sunway Pyramid, Publika, Bangsar Shopping Centre and Bangsar Shopping Village. Central Market, a delightful art deco building dating back to 1936, is a one-stop destination for Malaysian and regional souvenirs.

While the leading shopping malls offer a sense of being in Malaysia since their food courts serve local dishes, they mostly mimic Western shopping malls. For something more local, visitors head to Petaling Street in Chinatown, Brickfields for Indian merchandise and the various night markets scattered around the city.

Towards the end of the decade after independence, Malaysia set about erecting new buildings to commemorate the new nation. Parliament House was one such building as was the National Mosque or Masjid Negara with its Modernist design principles. Unlike many mosques which have a domed roof, the National Mosque looks like an umbrella from the top. The National Library, shaped like a traditional Malay headdress or *songket tengkolok* is a striking building as is the National Art Gallery located just down the road. In suburban Bukit Kiara a large geodesic dome houses the National Science Centre.

Opened in 1998, the Islamic Arts Museum of Malaysia has the region's largest collection of Islamic art. The museum building is modern, with Islamic detail and turquoise-tiled domes on the roof. Its collection houses over 7,000 artefacts, which are complemented by an exceptional Islamic art library. Displays range from intricate jewellery to scale models of the Masjid al haram in Mecca. Collections from Asia, India, China and Southeast Asia dominate but the 12 galleries are displayed along themes rather than geographical origins.

Above: After independence in 1957, many landmark buildings were constructed with Parliament House being an important statement of nationhood.

Opposite left: Traditional Malay life is portrayed around the capital with a Malay kite or *wau* incorporated into a sign near Chinatown.

Opposite right: The street decorations in suburban Brickfields are Indian in style, to complement the shops, temples and restaurants here.

KUALA LUMPUR AND SURROUNDS

AROUND KUALA LUMPUR: PUTRAJAYA

PLANNED ADMINISTRATIVE TERRITORY

Malaysia's Multimedia Super Corridor is a joint public and government initiative to enable Malaysia to be part of the global information technology scene. It stretches from KL to KLIA and includes the planned satellites of Putrajaya and Cyberjaya. To the south of KL, Putrajaya is the nation's new administrative capital, while adjacent Cyberjaya is home to information technology development and includes university campuses and private research facilities. Both only date back to the turn of the century where palm-oil estates had once stood. Spacious gardens and lakes provide a green environment and relaxing place to live.

Most federal government ministries previously housed in KL's landmark architectural buildings have relocated to the administrative capital of Putrajaya. The architectural style for some takes its inspiration from Islamic-Mogul elements but these have been contemporized in many cases. Putra Square or Dataran Putra is the ceremonial centrepiece and the massive Perdana Putra of the Prime Minister's Department adjoins the square. Putrajaya is extensive (covering almost 5,000 ha (12,355 acres) and, at first sight, seemingly devoid of people but they are here in their hundreds of thousands. Being so spread out, it's not a good place to walk around, so an organized tour or a self-drive car are essential prerequisites. However, there are parts where it is very rewarding to walk or cycle, such as along the trails near the Pullman Lakeside Hotel. There is a small sandy beach and an Olympic-sized swimming pool close to the Pullman. Keen cyclists ride from Kuala Lumpur to this part of Putrajaya and back at the weekends.

Above: The Tuanku Mizan Zainal Abidin Mosque in Putrajaya is popularly known as the 'Iron Mosque'.
Opposite: Putrajaya is built around a series of constructed lakes and sections are devoted to watersports.

KUALA LUMPUR AND SURROUNDS

Putrajaya Botanical Gardens (Taman Botani), covering 90 ha (222 acres), are an important educational, scientific and recreational asset. With over 700 species from some 90 countries on display, visitors can discover the rich bounty of tropical plant life. There is a hands-on interpretation centre that especially appeals to children. All visitors can enjoy the colourful tropical flowers along the Heliconia Trail, in the Sun Garden and amongst the African Collection.

The impressive 76-m (249-ft) tall Putra Mosque is one of the most striking buildings located on the foreshores of the lake. There are eight grand bridges with the Seri Saujana, Seri Bakti and Putra Bridges being the most architecturally significant.

Right: Putra Mosque is the principal one in Putrajaya with a capacity of 10,000 worshippers.
Below: Seri Gemilang Bridge connects Putrajaya's Heritage Square with the International Convention Centre.
Opposite: The Seri Saujana Bridge in Putrajaya is a cable-stayed, arch crossing similar to the Sydney Harbour Bridge.

The Sepang International Circuit just near KLIA is the home of the Petronas Malaysian Formula One Grand Prix track. The race is known as the hottest on the Grand Prix circuit not only for the temperature on the track but also for the challenging track design. Enthusiasts get a superb view of the race from a double-frontage grandstand immediately in front of the pits, the only race track in the world to have such a feature.

AROUND KUALA LUMPUR: SELANGOR STATE

The Federal Territory of Kuala Lumpur is surrounded by the state of Selangor but the boundaries between the two blur. One noticeable point of demarcation is the ceremonial gates on the Federal Highway on one of the main traffic arteries radiating from Kuala Lumpur to the satellite city of Petaling Jaya.

Selangor state (officially Selangor Darul Ehsan) is Malaysia's most populous and includes two of the city's oldest residential areas in Petaling Jaya and Shah Alam. Both are planned new town satellites with the latter being the state capital. Petaling Jaya or 'PJ' was the first to be built with proper town planning principles and appropriate infrastructure. Much of the land was a rubber estate and development began in earnest in 1953 with the original plots selling for RM200 – a bargain by today's prices.

Discussions on relocating the Selangor state capital from KL started as early as 1956 but it wasn't until 1964 that Shah Alam, halfway between KL and the port of Klang, was decided upon.

The pools in suburban KL that resulted from tin-mining have been incorporated into various developments. One of these is Sunway Lagoon in suburban Petaling Jaya, a 44-ha (200-acre) integrated water theme park that includes hotels, watersports, shopping and a spa. Families especially enjoy all the thrills in the World of Adventure, the Wild, Wild West and Waters of Africa.

Both Petaling Jaya and Shah Alam have parklands, urban forests and lakes that provide recreational space for the locals and tourists. Bukit Gasing is a forested area in Petaling Jaya that is popular for walking, while Shah Alam Botanical Gardens at Bukit Cahaya is a multi-purpose forested area. The latter started as an agricultural park and is often still known as that but now the locals use it for walking, cycling, picnics and overnight stays in chalets. Four Seasons House and agricultural displays, such as rice fields and spice gardens, appeal to many while adventurous visitors head to Skytrex Adventure for thrilling exploits in the rainforest canopy.

The Shah Alam skyline is dominated by the Sultan Salahuddin Abdul Aziz Shah Mosque. The mosque is better known as the Blue Mosque after its dominant blue domes. Its 142-m (466-ft) high minarets are some of the world's tallest and several thousand worshippers can fill the interior during prayers.

Batu Caves on the northern outskirts of KL are cavernous spaces that have religious significance for Hindu worshippers especially during the Thaipusam festival in February (see page 49). Visitors and worshippers have to climb a long flight of stairs to reach the caves and the religious icons contained within.

The rainforests of Malaysia are well known as a habitat for numerous and unique animal species. However, many visitors do not have the time to visit the wilds of Malaysia to see its wildlife first hand. For those with limited time, Zoo Negara located at Hulu Kelang just 13 km (8 miles) from the city centre is an accessible venue in which to see some of the country's unique fauna. It houses some 200 animal species including tigers,

Orangutans, tapirs, primates, deer, elephants, birds and reptiles in semi-natural habitats. The zoo's latest attraction is the Giant Panda Pavilion that houses two pandas – Fu Wa and Feng Yi.

City residents and visitors don't have to travel too far to enjoy some tranquil natural surroundings. The Forest Research Institute of Malaysia (FRIM) in Kepong is one of the closest being just 30 minutes drive from the city centre. While FRIM serves an important role for rainforest research, visitors can learn more about the habitat by negotiating several trails, inspecting the arboretums and herb gardens and checking out the museum. There's also a suspended walkway high up in the canopy.

Templer's Park to the north of Kuala Lumpur has several trails, towering limestone cliffs and cascading waterfalls. It's a popular picnic spot at the weekend for the local population.

The coastal fishing village of Kuala Selangor one hour (64 km/40 miles) north of KL is located where the Selangor River meets the Straits of Malacca. There are several historic attractions, seafood restaurants overlooking the river and an ecotourism destination at Kuala Selangor Nature Park (Taman Alam Kuala Selangor). The park was salvaged from a failed golf course development and is now jointly operated by the Malaysian Nature Society and the state government as a valuable wetland habitat for resident and migratory birds that rest here on their north-south migration. Covering 324 ha (800 acres), it includes ponds, secondary forest, birdwatching towers and valuable stands of mangrove along the coastline. Visitors can stay here in simple chalets or in hotels in the town. The park is best visited at dawn or dusk when the wildlife is most active. Walking the exposed trails at other times can be demanding due to the heat and humidity but there are several shaded hides for serious birdwatchers to get glimpses of the 156 resident and migratory birds that have been recorded here. Sightings of rare birds like the Spoon-billed Sandpiper and Nordmann's Greenshank have been made. Other animals such as otters, lizards, monkeys and langurs can also be spotted.

Many day visitors travel here in the afternoon, then go to nearby Kampung Kuantan in the evening to be boated along the tranquil river to see the millions of twinkling fire flies that light up at night in the vegetation lining the Selangor River. Tour operators can arrange trips from Kuala Lumpur to the village. Local boatmen silently paddle visitors along the river in small wooden boats and the experience is a truly memorable one.

The remains of a 200-year old Dutch fort are located near Kuala Selangor. Altingsburg Lighthouse perched on top of Bukit Melawati offers a shaded area for picnics and an elevated position from which to view the park, town and Straits of Malacca. The fishing village of Pasir Penambang on the other side of the river has some excellent seafood restaurants beside the river; the quality is superb and the prices amazingly cheap.

Above: Kuala Selangor is a small fishing village north of Kuala Lumpur, well-known for its seafood restaurants beside the river.
Opposite: Hindu worshippers have to negotiate 272 steps to reach Temple Cave at the famous religious site of Batu Caves.

CHAPTER III

NEGERI SEMBILAN, MELAKA *and* JOHOR

Southern Gateway

The state of Johor is situated at the south of the Malaysian peninsula, linked to Singapore by a causeway which also marks the start of the North-South Expressway that travels northwards to the border with Thailand passing to the south of KL through the states of Melaka and Negeri Sembilan along the West Coast. There are two crossings into Singapore – the Johor-Singapore Causeway and a bridge known as the Second Crossing at Tuas. Ferries for Indonesia (Batam Island), Singapore and outer islands depart from either around Johor Bahru or closer to the Johor Islands just off the East Coast.

Left: The Straits Mosque Melaka (Masjid Selat Melaka), which opened in 2006, is located on a constructed island just offshore from Melaka and at high tide it looks like it is floating on the waters of the Straits of Malacca.

NEGERI SEMBILAN

Sembilan is the local word for 'nine' referring to the nine mini-states that make up the state (*negeri*). Its capital is Seremban and its royal capital is Seri Menanti, home of the head of state, the equivalent of a sultan.

Negeri Sembilan has a history noted for the dominant influences of the Minangkabau people, who migrated across the Straits of Malacca from Sumatra in the 12th century. Their culture, ceremonies and traditions that continue to be observed in various communities throughout Negeri Sembilan distinguish

it from the rest of the peninsular states. The traditional houses of these people are identified by sweeping roof lines and peaks shaped like buffalo horns. Some excellent examples of the style can be seen at the State Mosque and the old State Secretariat Building (Wisma Negeri) in Seremban.

Historical accounts note that the people lived peacefully and had no wish to form their own sultanate. Instead they initially accepted the authority and protection of neighbouring Malacca while retaining customs and self-governing practices based upon their Sumatran heritage.

Minangkabau culture is founded on the co-existence of a matriarchal society and a nature-based philosophy called *adat perpatih* (shortened to *adat*). In essence, *adat* has its foundations in thousands of traditional proverbs that have been identified for every human endeavour, and each is usually expressed in beautiful words.

Traditionally, the power of Minangkabau women extended to the economic and social realms of village life as women controlled land inheritance and husbands moved into their wife's household. Despite the special position women are accorded in society, the Minangkabau matriarchy is not equivalent to female control or rule as their husbands still play a substantial role in justice and helping run the family.

Above left and opposite: The Negeri Sembilan State Museum Complex in Seremban showcases Minankabau culture and history, including an example of an old wooden palace (left).
Above right: Minangkabau architecture with its distinctive curved roof lines is found throughout Negeri Sembilan.

NEGERI SEMBILAN, MELAKA AND JOHOR

There are several places to visit in the state including Seremban, the forest reserve of Ulu Bendul, the royal town of Seri Menanti and Port Dickson, a seaside resort town.

The state capital Seremban, 64 km (40 miles) south-east of Kuala Lumpur, with its 500,000 inhabitants accounts for half the state's population. The State Museum (Muzium Negeri) and Cultural Handicraft Complex (Taman Seni Budaya) feature traditional Minangkabau architecture. Both are located on Jalan Labu just near the exit to the North-South Expressway. The handicraft complex houses a fine display of craft items and

Above: Negeri Sembilan's original State Secretariat Building was completed in 1912 in Victorian Tudor style.

Right: Seremban, the state capital, started with the discovery of tin ore in the 1870s. It began with just two rows of shophouses to service the mining community.

NEGERI SEMBILAN

historical artefacts. The State Museum includes an old wooden palace, which was relocated and re-assembled on its current site. Known as Istana Ampang Tinggi, it dates back to the 1860s and was originally located near the royal town of Seri Menanti. Built entirely of wood without any nails, it houses various historical artefacts, such as weapons, brassware and silverware.

Just out of the commercial heart of the city are the tranquil Seremban Lake Gardens. These picturesque and well-maintained gardens house lush greenery and manicured lawns making them ideal for recreation, family picnics, games and quiet relaxation. The gardens are quite extensive as there are two lakes, a jogging track, children's playground and a mini bird park.

Port Dickson is a small coastal town located 90 km (56 miles) south of Kuala Lumpur and 32 km (20 miles) south-west of Seremban, connected to them by freeways. It was developed as a port by the British during the Straits Settlement period, then evolved into a busy trading centre and a now-disused railway line was constructed to facilitate its growth. There has been some recent discussion about reopening the line to enable tourists to visit the town and adjoining beaches.

Port Dickson has 18 km (11 miles) of beaches with shallow waters dotted with shady coves lined with casuarina and banyan trees. While the beaches may not be Malaysia's best, they are very popular with locals and city folk who travel down here from Kuala Lumpur for the weekend. The light sea breeze from the Straits of Malacca and the afternoon setting sun make it a relaxing and picturesque destination.

Yachting enthusiasts can stay at one of several resorts here or at Admiral Cove Marina Resort were luxury yachts are moored. The marina attracts international sailors passing through the Straits of Malacca as it includes clubhouse facilities, recreational outlets, restaurants and bars, and accommodation.

Opposite: Port Dickson is the closest seaside resort to Kuala Lumpur, where beaches attract many local holidaymakers and a marina provides facilities for international and local sailors.
Below: Seremban Lake Gardens provide a tranquil retreat with various walking paths, landscaped gardens and a lake.

NEGERI SEMBILAN

NEGERI SEMBILAN, MELAKA AND JOHOR

The forested hinterland of Negeri Sembilan is excellent for jungle trekking and mountain climbing. The most accessible areas are the Ulu Bendul forests and waterfalls, and forests around Jelubu and Kuala Pilah.

The Recreational Forest at Ulu Bendul (Hutan Lipur Ulu Bendul), 20 km (12 miles) east of Seremban on the road to Kuala Pilah and Seri Menanti, lies at the foot of Mount Angsi, which rises to 825 m (2,707 ft). One of the park's attractions is that it's just a little over an hour from Kuala Lumpur and yet is in the middle of the Malaysian rainforest.

Tucked amidst green hills 50 km (31 miles) from Seremban, the tranquil royal town of Seri Menanti is the official residence of the sultan as well as the site of the Seri Menanti Royal Museum. This former palace was converted into the Royal Museum in 1992 and is a classic example of Minangkabau architecture and design. Built at the turn of the last century by two local artisans, the wooden structure is an architectural feat as no nails were used in its construction. It incorporates 99 pillars which represent the 99 warriors who once served the palace. Today, it houses the regalia of the Negeri Sembilan royal family, with exhibits such as costumes, ceremonial weapons and official royal documents.

MELAKA

Melaka (previously known as Malacca) plays an important role in Malaysian history as it was one of the first ports established and held a preeminent role in regional trade for several decades. Its history is complex having been shaped by neighbouring Sumatra, the Portuguese, Dutch and British, and now modern-day Malaysia. It reached the zenith of its power in the 16th century with a population of 100,000 and was one of the world's most important ports attracting sailors and traders from many parts. Records suggest that Chinese traders bearing porcelain and silk had been passing through the straits for centuries before. Admiral Cheng Ho made at least seven voyages from China to the region from 1405 to 1431. It became a cosmopolitan settlement where the local Malays mixed with Chinese, Indian and European settlers.

Right: Istana Lama at Seri Menanti is the old palace of the sultan of Negeri Sembilan. It was built entirely without nails.

In 1507, the Portuguese first arrived in Melaka and returned in 1512 to conquer the port. They established a fine fort called A'Famosa ('The Famous'), the remains of which, Porto de Santiago or Santiago Gate, can be seen today at the bottom of St John's Hill. Melaka remained under Portuguese control until 1641 when the Dutch East India Company claimed supremacy but by this stage, Melaka was a shadow of its former glory. However, the Dutch set about establishing public buildings and urban infrastructure. They encouraged trade and traders to establish their businesses in the port and the Chinese, in particular, took a foothold on commercial activities which they still retain.

The Dutch remained until 1786 when Melaka came under the control of the East India Company based in England. It was administered by the British from 1795 until 1824 when it was officially reassigned to Britain via the Anglo-Dutch Treaty signed on March 17, 1824. In 1825, the British occupied the port under the direct authority of the English Bengal Government in India.

The Portuguese, Dutch and British all stamped their mark on this historic city with many of the former colonial buildings now being an essential part of Melaka's historic fabric, visited each year by millions of tourists.

Many of Melaka's streets are well known but none are more famous than Jonker Street. While its name has been changed to Jalan Hang Jebat many still refer to it by its Dutch name. The old streets, colonial buildings and trading houses attract tourists to the UNESCO World Heritage Site (a joint site with George Town, Penang). One of the best places to admire the whole heritage city centre is from St Paul's Church on the hill behind the main colonial buildings. Built in 1512, St Paul's is a popular tourist attraction and excursion site for local students. Francis Xavier, a Roman Catholic missionary to Africa, was a regular visitor and was temporarily buried here for nine months after his death in China and before final transportation to India.

The architectural fabric of present-day Melaka is best described as eclectic and visually stimulating as something new awaits at every road intersection. The most famous public buildings are located in what is known as Town or Dutch Square. Most are painted dusty red just as they were during the colonial era and have even led some to call this Red Square. The beautiful 18th century Christ Church is the most striking building but others include The Stadthuys or former Governor's residence, and the clock tower and fountain. Visitors could well be forgiven for thinking they were in old Amsterdam while standing in front of the Christ Church and the neighbouring Stadthuys. The stately church built in 1753 is the oldest functioning Protestant Church in the country.

Above: The picturesque Dutch Square is the place to start exploring the many heritage buildings located in the historic port city of Melaka.
Opposite: Now a UNESCO World Heritage Site, Melaka's core protected zone covers some 39 ha (96 acres), which is surrounded by a 143-ha (331-acre) buffer zone.

NEGERI SEMBILAN, MELAKA AND JOHOR

The best place to begin exploring the heritage city on foot is in its centre near the bridge over the Melaka River built on the site where Portuguese soldiers took the port in 1511. The Melaka River is also an historic landmark. It's possible to go on river cruises to gain an insight into the lifestyle of the people currently living along the river and to learn about the past at the same time. While some goods still come into Melaka via the port it is nowhere near as vibrant as it once was.

Just across the Melaka River, the historic commercial city centre is dominated by old two-storey shoplots. Some of these remain intact but others have been modernized over the past few decades. It's best to explore Chinatown by walking along the sheltered 'five foot walkways' (see also page 34). Many old crafts

and trades are still practised here but most of these have been relegated to the back streets and visitors need to search for them.

Jalan Tun Tan Cheng Lock was once known as Melaka's 'Millionaires Row' and there are some fine examples of Baba Nyonya-styled (or Peranakan) houses along the street. The best location to appreciate the lifestyle of the Baba-Nyonya is the Baba and Nyonya Heritage Museum. Faithfully preserved and maintained as a traditional Peranakan townhouse, it offers a wonderful insight into just how these people once lived.

Melaka's tourism officials set about many years ago to distinguish the city from others by establishing a myriad museums. Visitors could spend several days and still not see them all. While most revolve around Melaka's heritage, others seem to be totally unrelated to history at all.

It's possible to learn more about Melaka's past at the History and Ethnography Museum located in the Stadthuys. Melaka's maritime history is documented in the Maritime Museum situated next to a huge replica of *Flora de la Mar*, a Portuguese vessel that sank in the Straits of Malacca. Other museums in the downtown area include Muzium Budaya (at the base of St Paul's Hill) which is a large wooden replica of a Melaka sultan's palace. Muzium Rakyat near the Porto de Santiago showcases local society and the economy.

Perhaps the city's most unusual museum is situated above the Muzium Rakyat. The Museum of Enduring Beauty explores how people around the world beautify themselves. Such things as tattooing, body scarring, foot binding, cosmetic surgery and piercing, make for an unusual and fascinating display.

Many visitors to Melaka hire a trishaw for a nostalgic cycle past the heritage buildings. All trishaws are ornately decorated and there is always some friendly tourist patter from the well-meaning drivers. Some have onboard music machines to add to the excitement and theatre of it all.

Medan Portugis lies about 3 km (2 miles) south-east of the city and is home to Malaysia's Eurasian community which has lived here for over 400 years. The actual square, based upon a Portuguese *mercado* (market), only dates back to the 1980s but it is a lively place from the time the sun sets until late into the evening. The otherwise sleepy village is far from scenic but the view over the Straits of Malacca at sunset makes for a memorable place to dine on such dishes as chilli crabs and prawns plus a Portuguese-inspired *debal* curry.

Ayer Keroh, 15 km (9⅓ miles) from the city centre, is a hub for tourism with attractions such as the Melaka Zoo, Hutan Rekreasi Air Keroh (Air Keroh Recreational Forest), Taman Mini Malaysia and an Orang Asli Museum.

Opposite page: Often it is the small details that set a heritage site apart and visitors to Melaka will enjoy slowing down to look at the city's heritage on a macro scale.
Below: Visitors can explore historic Melaka in a colourful trishaw.

JOHOR

Malaysia's southernmost state of Johor is the gateway for those arriving into the country from Singapore. Covering an area of 18,841 sq km (7,275 sq miles), it is Malaysia's third largest state. The capital of Johor Bahru, known to most as 'JB', is a city worthy of exploring in its own right but it is also a useful base from which to travel throughout Johor. The state offers attractions from beaches and islands along the East Coast to the bustling capital as well as nature and agro-tourism encounters in rural parts. One of Malaysia's largest infrastructure developments is also unfolding in the state. Iskandar Malaysia covering 2,215 sq km (855 sq miles) is a planned city that will, when finished, cover an area almost three times larger than the neighbouring island of Singapore. Five distinctive zones are under construction including the state administrative capital of Nusajaya, Legoland Malaysia and Pinewood Studios.

One leading tourist attraction in JB is the former residence of the Sultan of Johor who is the constitutional head of the state. The sultan has moved to the outskirts of JB and the former residence overlooking the Straits of Johor is now the Sultan Abu Bakar Museum and Grand Palace. The museum provides an interesting perspective on the lifestyle enjoyed by the sultans and their families. The view across the gardens, the Straits of Johor and into Singapore makes a visit worthwhile.

Johor Fort on Bukit Timbalan is an imposing building located on the highest point in the downtown area. It was originally the headquarters of the Royal Johor Military Force which was formed in 1855 by Sultan Abu Bakar and remains as the sultan's own private army.

The historic inner core of Johor Bahru is slowly being overshadowed by tall offices and shopping malls. Historic streets such Jalan Tan Hiok Nee, virtually a pedestrian thoroughfare, are well worth walking along. There are some fascinating old buildings exhibiting various types of architecture.

On the outskirts of the capital Asia's first Legoland theme park includes 40 rides, shows, displays, 4D films and design areas using Lego blocks. Miniland features models made from Lego blocks of landmarks and scenes from around the world.

While there are some reasonable city beaches along the Johor Bahru waterfront at Stulang Laut and Lido, the East Coast is where the state's finest beaches and islands are situated. The 26-km (16-mile) expanse of sandy beaches of Desaru is home to resorts and golf courses with more planned.

The 50 or so Johor islands are some of Malaysia's more remote landforms, although some are serviced by ferries which depart from ports like Mersing, just 126 km (75 miles) from JB, and Tanjung Leman Jetty, 114 km (71 miles) from the state capital. Some of the islands are uninhabited while diving islands, such as Pulau Aur, have only limited accommodation.

Other islands have well-established resorts but the great attraction is that nothing is on a large scale with some offering a Robinson Crusoe experience. Being some distance offshore, all the islands have clear waters and are very popular with divers. Swells during the monsoon season from October to March often limit accessibility to certain islands.

Above: The maritime border between Singapore (left) and Malaysia is the Straits of Johor with a road and rail link called the Causeway.

Endau-Rompin National Park, straddling the Johor-Pahang border on the Johor's East Coast is a vast wilderness covering 80,000 ha (198,000 acres). The park was gazetted to protect vast areas of natural forests that date back many millions of years. This also meant the animals were protected, which is good news for the critically endangered Sumatran Rhinoceros, which has been recorded, but rarely seen, in the park. While spotting animals is always difficult in the rainforest, the Asian Elephant, Malayan Tiger, Tapir, White-handed Gibbon, deer and various monkeys are found here.

Gunung Ledang (also known as Mount Ophir) at 1,276 m (4,186 ft) high lies in the north of Johor on the border with Melaka. The mountain is often shrouded in cloud making it a conspicuous landmark. It is one of Malaysia's most accessible mountain areas making its rivers and waterfalls popular recreational playgrounds. The ascent of the mountain can be strenuous and the walks become quite congested at the weekends. The actual ascent involves a near-vertical cliff climb towards the summit. It is compulsory to go with a guide. The sparser mossy forest near the top is markedly different from the lowland dipterocarp forest with the trees being covered in lichens and mosses.

Agrotourism, to see the fruits of the farms, such as pineapples, oil-palm and rubber trees, is popular in Johor. Oil-palm and rubber-tree estates cover many parts of the state and visitors who travel by train will see little else as they pass through.

Johor is also well known for being one of Malaysia's leading golfing states as there are some 30 courses to play on, ranging from city clubs to nine-hole courses in remote oil-palm estates and East Coast beaches. Some of the best names in golf design, such as Arnold Palmer, Jack Nicklaus, Gary Player and Robert Trent Jones, have been involved in establishing the courses. Among the best-known courses are the 18-hole championship courses at Desaru Country Club and at Pulai Springs Resort.

The prestigious sailing event, the Monsoon Cup, has relocated from Terengganu to Johor. It is the final event in the Alpari World Match Racing Tour and is contested in the waters off the Country Garden Danga Bay in February.

Left: Johor's proximity to Singapore has seen massive infrastructure development, such as Puteri Harbour in Nusajaya, just one of several luxurious waterfront developments.

CHAPTER IV

NORTH *by* NORTH-WEST

States of Perak, Penang, Kedah (Langkawi) and Perlis

The North-South Expressway heads out of Kuala Lumpur to connect the four states north of the capital on the West Coast. These include the states of Perak, Penang (the island and a strip on the mainland), Kedah and Perlis.

Left: Langkawi's SkyBridge is accessible via the SkyCab cablecar to the summit of Mount Machincang and is located 100 m (328 ft) above the ground to give a unique panoramic view of the rainforest canopy.

PERAK

At 21,035 sq km (8,122 sq miles), Perak is the second largest state in peninsular Malaysia and almost half of its total area is covered by tropical rainforests in the interior or mangrove forests along its coasts. Perak means silver in the local language, although tin is the metal for which the state is best known. In the late 19th century, the world's richest alluvial tin deposits were mined in and around Ipoh, the Perak state capital. Tin was important then for plating iron cans to preserve food and miners from around the world arrived in Perak to sluice the metal from the alluvial deposits in the Kinta River.

The closest visitors will come to tin now is at The Lost World of Tambun theme park on Ipoh's outskirts, which has a tin mining display. Visitors to the water park can see and participate in a *dulang* washing activity (panning) where they separate water and mud from the heavier tin ore.

Perak was also home to the first planting of rubber trees from seedlings brought to Malaysia by the English botanist, H. N. Ridley in 1877 and which soon after became the mainstay of the Malaysian economy continuing throughout the 20th century. In other parts of the state there are old historic towns and villages, vast tracts of rainforest and several islands off the coast that are popular holiday destinations.

Most visitors to Perak drive to Ipoh as it is just a two-hour journey north of KL along the North-South Expressway. There is also a domestic airport and new electric trains have made arriving by train fashionable once again. Ipoh Railway Station is a grand colonial building known locally as the 'Taj Mahal of the North'. It was built in the late-1800s and is an impressive landmark combining Mogul architecture with modern embellishments. It also houses a hotel.

There are several landmark buildings within walking distance of the station, such as the all-white, colonial Town Hall

immediately opposite. Just past the High Court is the Royal Ipoh Club facing the expanse of *padang* and with a Tudor-styled clubhouse that resembles KL's Royal Selangor Club.

Opposite the Royal Ipoh Club the imposing three-storey St Michael's School is a historical building of national significance. The school features decorated gables and wide arched verandahs, running the length of the building.

Just north of Ipoh, Perak's royal town of Kuala Kangsar is situated beside the Perak River. Istana Iskandariah (the official residence of the Sultan of Perak) is a majestic building on Bukit Chandan and the golden onion dome of Masjid Ubudiah is a stunning sight that dates back to 1917. The main dome of this royal mosque is surrounded by four white minarets, which are also crowned with their own smaller golden domes. Other interesting architecture here includes the Malay College, Polo Pavilion Tower Square and Istana Kenangan, a former temporary residence of the sultan. The latter is mostly made from wood without the use of nails or screws. This photogenic white, yellow and black building was the official royal residence from 1931 to 1933. One of the first rubber trees to be planted in Malaysia grows in front of the District Office near the town centre. It was planted in the 1870s by British resident, Hugh Low. Kuala Kangsar is also home to one of Malaysia's elite boys' schools, the Malay College. Celebrated author Anthony Burgess (*A Clockwork Orange*) taught here in 1954.

Above left: Ubudiah Mosque in Kuala Kangsar is Perak's royal mosque.

Above right: The former Perak royal residence in Kuala Kangsar is a colourful building with shingles on the roof.

Opposite: Officially opened in 1917, Ipoh Railway Station became known by the locals as the 'Taj Mahal of the North'.

Taiping, the second largest town in Perak after Ipoh, lies in the north of the state. Its past importance as a thriving mining town is now hidden under the greenery of the gorgeous 62-ha (148-acre) Lake Gardens. It's also home to the Taiping Zoo which is the oldest in Malaysia and the Taiping Museum. The zoo is open daily and has a night safari that is worth investigating. On the outskirts of town, on the way to the base of Bukit Larut is the Commonwealth Allied War Cemetery for soldiers killed in the district during the Second World War.

Bukit Larut, formerly known as Maxwell Hill, located just above Taiping is the oldest hill station in Malaysia. The start of the hill climb is just minutes from central Taiping. After a winding forest drive up the 1,000-m (3,281-ft) high hill, the view from the summit's Larut Rest house can be magnificent on a clear day. Bukit Larut was once a tea plantation and now appeals to adventurous travellers seeking a cool location without the trappings of Malaysia's other hill stations.

Beaches on the West Coast of the peninsula are generally not as good as those on the East. Pangkor and Langkawi Islands are the exceptions with much of the former covered in pristine rainforest, white-sand beaches and a few bustling fishing villages. The main island is popular with locals and budget travellers, although there are a few international resorts.

While there is an airport on Pangkor it is now only used for charter flights. The alternatives are to fly to Ipoh, be driven to Lumut, then catch a ferry, or drive for four hours from KL. Once there, the cares of the world are a long way away so the island is perfect for those who like extended holidays in one location. The smaller and private island of Pangkor Laut is home to the luxurious Pangkor Laut Resort. With just one resort on the island, guests are guaranteed an exclusive and private holiday.

The largest expanse of tropical rainforest in Perak is known as the Royal Belum Forest of some 118,000 ha (291,584 acres) located in the far north along the border with Thailand. Most

of the area is a wilderness and home to many species of flora and fauna including several large mammals such as the Seladang, Asian Elephant, Malayan Tiger and possibly the highly endangered Sumatran Rhinoceros. Belum forests are dissected by the East-West Highway which crosses the Temenggor Dam built in 1978 for hydropower generation. The highway connects Gerik (Perak) with Jeli (Kelantan) and while hilly it is one of Malaysia's most scenic drives; an adventurous journey for self-drive visitors seeking an encounter with rural Malaysia.

Left: Pangkor Island has several pleasant beaches where the forests meet the sea.
Below: There are now two bridges that connect the island of Penang to the mainland.

PENANG

There are two Penangs; one is the island and the other the state. The island comprises the majority of the state with the remainder being a narrow strip of land on the mainland known as Seberang Prai. Trains terminate at Butterworth on the mainland and there are combined car and passenger ferries across the narrow stretch of water that connects the island to the mainland. Motorists use two of Southeast Asia's longest bridges that cross the Straits of Malacca to the island.

At 1,048 sq km (405 sq miles), Penang is the nation's second smallest state (Perlis is the smallest). While densely populated, the majority of its 1.2 million residents mostly live around the island's coastal fringes. Being 12 km (7.5 miles) wide by 24 km

(15 miles) long, it's possible to drive around the island in half a day. While there are several pleasant beaches and deluxe resorts at Batu Ferringhi, it is George Town's heritage that makes Penang so unique.

Penang has a short but interesting history that really only dates back to 1786 when the British East India Company under the command of Captain Francis Light claimed the island for the company. It was initially called Prince of Wales Island and the capital was named after King George III. The British handed control to the Malaysians when independence was declared.

Fort Cornwallis was one of the first public buildings erected but the remains of the current fort are actually those of the second fort built in 1793 from stone and brick. The fort's commanding harbourside location provided protection for the settlers. It overlooks a large open grassy area known as the *padang* at the northern end of which is the grand Town Hall. Initially, Penang's public facilities were limited and simplistic in design but eventually a street grid was established and better amenities put in place.

The narrow streets and landmarks of the historic centre are now a UNESCO World Heritage Site (a joint site with Melaka in the south) officially known as the Historic Cities of the Straits of Malacca. George Town with its 13,000 pre-Second World War buildings is unique. Many buildings are undergoing restoration.

Most of Penang's Chinese shophouses and houses have several common features. Two or three floors high, they have narrow street frontages but are deep with spacious interior air wells to enable light and air to enter. They were usually built from brick in terraces with uniform but often elaborate façades and construction reached its peak in the 1920s during the rubber boom.

Immigrant workers lived together for security and companionship, and enclaves called *kongsi* (societies) were established. These served as dormitories and meeting places while also offering bank and employment services for Chinese immigrants originally from the same region or village, most of whom were Hokkien or Cantonese. Several of these are open to the public. Khoo Kongsi has been meticulously renovated. This semi-medieval kongsi in Cannon Square was home to Hokkien Chinese and features a clan temple and a stage for Chinese opera, located in various courtyards.

Above: Penang has what is considered the best preserved collection of pre-Second World War shophouses and townhouses in the region.
Opposite top: Visitors to the island of Penang can stay at one of several beachfront resorts at Batu Ferringhi.
Opposite below: Fort Cornwallis was erected to protect Penang, although the current brick-and-stone structure completed in 1810 has replaced the original stockade.

Many visitors use the abundant literature to explore historic George Town as there is something of interest around almost every corner. Bicycle hire shops do a roaring trade as the adventurous head off to explore the city's heritage and the recently installed street art. Hiring a trishaw is a more relaxed way to discover these attractions.

Below left: Old shophouses are being restored and converted to new uses, such as this boutique heritage hotel in Stewart Lane.

Below right: Many visitors hire bicycles to explore historic George Town with car-free Sunday mornings in parts of the heritage zone being the least congested time.

Opposite top: Penang City Hall is situated at the northern end of a large expansive open field called the Padang.

Opposite below: The beautifully restored interior of an old Penang Peranakan Mansion, now a museum.

STREET ART

An innovative street art programme provides another reason to explore historic George Town. Featuring mischievous trompe l'oeil murals incorporating existing wall features and added objects as well as 52 commissioned steel-rod caricatures, the street art brings new life to the city. Much of the interactive artwork was done by Ernest Zacharevic from Lithuania.

Leith Street is one of the more interesting streets with the magnificently restored Cheong Fatt Tze Mansion at the northern end. This 38-room mansion is now a boutique hotel and, while based on traditional Chinese architecture, also incorporates Western features, such as stained-glass windows and wrought-iron staircases. Its striking blue paintwork was widely used in the country during the 19th and early 20th centuries. There are also four red columns on the balcony, which denote the status of the prominent overseas Chinese businessman who built the house.

Armenian Street has informative street interpretation signs and many of its buildings have been restored to their original grandeur but now operate as cafés, galleries, shops, museums and boutique hotels. The restored former home of Syed Alatas (a leading politician in the 1960s and 70s and one-time Vice-Chancellor of the University of Malaya) is a museum and close by is the former home of Dr Sun Yet Sen (leader of the Chinese nationalist movement who lived in Penang from 1909 to 1911). Towering above all this is a building out of context with its neighbours. The Komtar is an office tower and Penang's tallest building also housing shops, restaurants and cinemas.

Other noted historic areas in George Town include the

Rope Walk (junk shops), Campbell Street (Chinese shops) and several imposing former colonial bank buildings.

Within a short distance westward of the busy Batu Ferringhi beachfront strip, the inland mountainous area is dominated by forests and farms. The main road here from the northwesternmost tip of the island heads southwards through villages, farmland, forested areas and a mangrove-lined coastline.

Left: Wrought-iron interpretation signs provide information on Penang's heritage assets.
Above: Once the private mansion of a wealthy entrepreneur, the Cheong Fatt Tze (or Blue) Mansion is now a boutique heritage hotel.

Malaysians love Penang for its hawker food which is considered some of Malaysia's best. Many locals visit specifically to dine here with the stalls located along the Gurney Drive seafront being especially popular. Some favourite dishes include prawn *lam mee* (yellow noodles in prawn gravy), *ikan bakar* (barbecued fish), *satay*, Penang *laksa* (curry noodles) and *burbur cha cha* (sweet potato in coconut milk).

Many visitors to Penang check into one of several resorts along the tranquil beachfront of Batu Ferringhi to enjoy the comprehensive range of leisure activities and services. Several tourist attractions are located in the area. The spacious forest and grounds of the Tropical Spice Garden are especially popular as well as the Penang Butterfly Farm and Tropical Fruit Farm, which is just a few kilometres out of Teluk Bahang. The Butterfly Farm has thousands of butterflies that thrive in the nectar-rich gardens. Visitors can walk through these gardens to admire over 50 Malaysian butterfly species. A little further south, the Tropical Fruit Farm grows and sells some 250 types of rare and exotic fruits. Most are tropical and sub-tropical fruits grown under an organic regime and tours plus fruit samplings are conducted.

The interior of the island is mostly forested. Penang Hill or Bukit Bendara (833 m/2,723 ft) is the island's highest point. Temperatures on the hill are cooler than the lowlands and it is where Malaysia's first hill station was established. The one-time home of William Halliburton (a former sheriff of Penang) has been converted into a hotel – the Hotel Bellevue – that offers a nostalgic experience similar to the 19th century when many colonialists sought refuge at the hill station. Penang Hill is accessible via the scenic and historic funicular railway that dates back to 1923. Operating from Ayer Hitam to the summit, it's a great 2-km (1¼-mile) journey passing through terraced slopes with old colonial homesteads and lush gardens. From the top there are several walking trails including one down to the expansive Botanical Gardens at the bottom of the hill. These gardens were originally established in 1884 by the British as the Waterfall Gardens. Now important green lungs for the island, the gardens are open daily for recreation, exercise and education.

Other tourist attractions are located around the island but visiting them means hiring a taxi or a rental car. Known as Balik Pulau or the back of the island, the western side of the island is an area not commonly visited by tourists.

Penang National Park of 1,213 ha (2,997 acres) on Penang's north-western tip is home to hiking trails, beaches, forests, camping facilities and a turtle hatchery on Pantai Kerachut beach which is operated by the Department of Fisheries. Lowland dipterocarp forest is the most common habitat in the park but there are some peat swamp forests that are typically low in nutrients and where species such as the pitcher plant thrive. The park's sandy beaches are mostly untouched; Pantai Kerachut and Pantai Ketapang are the most accessible.

Opposite: Penang Botanic Gardens dating back to 1884 provide a green lung to the highly urbanized, north-eastern side of the island.

THE E&O HOTEL

Penang's Eastern & Oriental Hotel (known as the E&O) is Malaysia's only grand heritage hotel. Once an essential stop for seafaring travellers on the 'grand tour of Asia' and billed as the finest hotel east of the Suez, the E&O continues a heritage and tradition dating back to 1885. It was built by the three Sarkies Brothers from Armenia who were also responsible for the opening of two other famous regional heritage hotels in Singapore's Raffles Hotel and The Strand in Yangon (then Rangoon). The E&O was restored in 2001 and facilities to accommodate contemporary travellers were incorporated while still maintaining the charm of a bygone era. An extension was undertaken in later years but the traditions live on in the 1885 Restaurant where traditional English afternoon teas are served daily and in Farquhar's Bar along the seaside promenade which allows guests to reminisce while watching the sun go down over the Straits of Malacca, gin and tonic in hand. The E&O has a sister heritage property called the Lone Pine along the beachfront of Batu Ferringhi.

KEDAH

Kedah in the north-west of the peninsula includes parts of the mainland and the islands of Langkawi just off the coast. Its capital is Alor Star (or Alor Setar) which has a domestic airport on the outskirts of the city. There is also an international airport on Langkawi. Kedah covers an area of 9,500 sq km (3,700 sq miles) and is mostly flat, which makes it suitable for growing rice. Known as Malaysia's rice bowl (along with neighbouring Perlis), the landscape is dominated by *padi* fields punctuated by rounded limestone outcrops.

Kedah has a long, forested and mountainous border with southern Thailand, where Lake Pedu, a large man-made lake with various nearby hotels, can be visited. Several road and rail border crossings make it easy to travel between Malaysia and Thailand. Bukit Kayi Hitam is the main road crossing into southern Thailand and the city of Hat Yai, while the train crosses the border at Padang Besar.

While best known as a holiday island of sand, sea and surf, the Langkawi Archipelago (there are 99 small islands in total) offers many interesting cultural aspects and a complex natural environment. Malaysia's most popular island resort destination also has several luxurious resorts and restaurants while duty-free shopping adds to its international appeal.

Development hasn't greatly affected the island's ecology or the islanders' lifestyle as most resorts blend into their natural surroundings, are low-rise and well-spaced around the main island. International hotel groups such as Four Seasons, Sheraton and Westin have resorts on the island, while Bon Ton Resort and the adjoining Temple Tree Resort offer one of Malaysia's most unique accommodation options of old wooden Malay houses. Bon Ton Resort is also home to one of Malaysia's most respected restaurants that introduced the dining concept of 'West meets spice'.

Top right: Langkawi Island is recognized for its luxurious, low-rise beachfront resorts.
Right: Temple Tree (pictured) and Bon Ton Resorts are unique in that they are a small cluster of traditional homes with luxurious interiors appointed with antiques and contemporary furnishings.
Opposite: Peaceful and near-deserted beaches attract tourists to the duty-free island of Langkawi in north-west Malaysia.

KEDAH

Opposite: Several waterfalls like Temurun on Langkawi provide a spectacular sight especially after periods of rainfall.
Left: The cable car and bridge located on Langkawi's Mount Machincang give wonderful views of the rainforest canopy.
Below: One of Langkawi's most popular eco-tours is to visit the extensive mangroves within the Langkawi Geopark.

Langkawi's rock formations are important in being some of the region's oldest dating back 550 million years. Parts of Langkawi are now a UNESCO Geopark (a nature reserve focusing on the geology), which not only protects the rocks but also the plants and animals. Volcanic granite rock forced its way through Langkawi's sedimentary layers to form the peaks of Mount Raya and Machincang. A cablecar operates on the latter and the views, to even as far away as the neighbouring islands of southern Thailand, are spectacular. There are several other attractions on the mountain including a bistro and boutique as well a thrilling curved suspension bridge that traverses the rainforest canopy.

Langkawi's natural environment of rocks, plants and animals make the archipelago unique. While many visitors come to relax in the sun, others can participate in a range of outdoor activities, such as jungle trekking, birdwatching, visiting waterfalls and taking boat trips to the outer islands. A tour through the island's coastal mangrove forests is a popular activity. Not only are the mangrove forests important for protecting the coastline, they also provide an exciting educational experience for visitors. The

gnarled mangrove roots are a habitat for fish and crustaceans, while monkeys and various birds make their homes in the foliage. Visitors can get a close-up view of scores of Brahminy Kites and White-breasted Sea Eagles soaring overhead. The rare Rainbow Lizard can be seen on some beaches darting from hole to hole in the soft sand.

Not for the faint-hearted, the Langkawi Rainforest Adventure will challenge those who take action seriously. This adventure involves rappelling, abseiling, crossing narrow crevices and flying through the rainforest canopy on a series of wires that resemble a Flying Fox zipline.

Langkawi's hidden charm is best found amongst the more isolated islands. Island hopping is popular with Pulau Dayang Bunting being the second largest island in the group and the one most commonly visited after the main island. Experienced sailors can also hire a yacht from Sunsail, a company based at the Langkawi Yacht Club in Kuah. For those less familiar with sailing, the services of a boat captain can be hired. With three other places to moor on the main island, sailing is becoming more popular and Langkawi is a regular stop for sailors using the Straits of Malacca. The straits and Langkawi are located along a sailing route from Singapore to Phuket that includes several islands along the western coastline of Thailand.

Payar Island is part of the Pulau Payar Marine Park (there are four small islands in the group) and is just one-hour's boat ride south of Langkawi. It is a well established snorkelling site with facilities such as a pontoon moored in the Straits of Malacca. These islands are uninhabited although the Fisheries Department has a Marine Park Centre with interpretation facilities. Boulder and brain coral can be seen and species such as the Black Barracuda, Giant Grouper, Clown Anemonefish and the harmless Black-tipped Reef Shark inhabit the waters.

Below: Passengers disembark at Dayang Bunting Island, one of the smaller islands surrounding the main Langkawi Island serviced by small boats.
Opposite: These rounded limestone hills in Perlis are typical of the karst topography of north-west Malaysia.

PERLIS

Malaysia's smallest state, Perlis, is situated in the far north-west of the peninsula bordering Thailand. In the state capital of Kangar, the former State Mosque of Masjid Syed Alwi is located near the centre of town. Built in 1910, it has a striking large black dome. The royal town of Arau, just a short drive from Kangar, is small with several distinctive buildings in the town centre. The Royal Palace, or Istana Arau, is a stately building situated opposite the large Royal Mosque.

Along with Kedah to the south, Perlis is known as the rice bowl of Malaysia. During the growing season, the flat parts of much of the state look like a sea of green with fields of rice stems swaying in the breeze. Just prior to harvesting, when the rice has ripened, the landscape changes to golden yellow. The fields are planted with two rice crops annually and while much of the work is now mechanized, village life is often determined by the rice-growing season.

Kuala Perlis, a small fishing village at the mouth of the Perlis River, is well known for the seafood served in coastal restaurants. While fish of all varieties are served, no dish is more popular here, and in many other parts of the Perlis, than *laksa*. The docks here bustle with activity as deep-sea fishing boats return with their catches. Kuala Perlis is becoming increasingly important as the departure point for ferries to Langkawi.

While most motorists heading north to Thailand cross the border in Kedah, there is a small border crossing in Perlis at Wang Kelian that provides an alternate route for those travelling to Hat Yai in southern Thailand. Life at this crossing couldn't be any sleepier for much of the week but it comes to life every Sunday morning when a market takes place with many stalls that are set up around the customs and immigration facilities of both Malaysia and Thailand. Thai and Malaysian traders and shoppers move freely between the two countries. The market is very localized but shoppers travel for hours just to participate.

There are several accessible caves in Perlis State Park near the border crossing. Back towards Kangar, Gua Kelam is a popular cave and recreational area near the settlement of Kaki Bukit. Wan Tangga Valley is located on the other end of a 400-m (328-yard) long, narrow boardwalk that meanders through a limestone cave. The route through the cave was established to transport tin ore to nearby Kaki Bukit town at the eastern end of the cave. The locals love to picnic and swim in the river at the cave opening.

Left: The extensive rice *padi* in north-west Malaysia is mostly mechanically harvested.

Above: There are several large caves in the limestone hills of Perlis with Gua Kelam at Kaki Bukit being a popular recreational spot with the locals.

EASTERN & ORIENTAL EXPRESS

Visitors to Malaysia can relive a bygone era when train travel was the main mode of transportation along the peninsula. Malaysia's first train line opened in 1885 and by 1909, Prai in the state of Penang was connected to Johor Bahru in the far south. Two of the grandest train stations in Malaysia are the Kuala Lumpur Railway Station (completed in 1911) and Ipoh Train Station (completed 1920). Both were designed by the same architect, A. B. Hubback, whose ideas were drawn from Mogul architecture in India.

Public trains operated by Keretapi Tanah Melayu (KTM) make the journey from Johor Bahru to Padang Besar in the north on the border with Thailand and from there all the way to the Thai capital, Bangkok and beyond. One of the world's most prestigious train journeys starts in Singapore and terminates in Bangkok along the same stretch of track. Private cabins on the Eastern & Oriental Express are plush and fitted out with luxurious beds; some have showers. Passengers can sit back and be pampered by the staff with morning and afternoon teas and pre-dinner drinks in the piano car. View the countryside on this grand train journey of 1,900 km (1,180 miles) from the open-sided observation car.

CHAPTER V

EAST COAST *and* CENTRAL

States of Kelantan, Terengganu and Pahang

Most Malaysians would refer to the East Coast of the peninsula as the strip north from Kuantan in Pahang to Kota Bharu in Kelantan near the Thai border but it also includes the coast southwards through to Johor state. The term 'coast' is a little misleading as there are also extensive inland areas to all of these states.

Left: Resorts are few and far between along the East Coast with Club Med at Cherating one of the most popular beachfront properties.

The main cities are the state capitals Kota Bharu (Kelantan), Kuala Terengganu (Terengganu) and Kuantan (Pahang). There are airports in each state to link them to the Malaysian capitals and, in some cases, to other destinations. The East Coast moves at a slow beat compared to the fast-paced West Coast. It is considered the heartland of Malay culture where religion, village life, and traditional arts, crafts and performances are still important.

KELANTAN

Kelantan is the northernmost state on the East Coast. To the north, the main border crossing at Sungai Kolok links Kelantan to Thailand's southern province of Narathiwat. The state has close relationships with southern Thailand and locals from both sides regularly cross into the neighbouring country. It is not surprising that Islam extends into southern Thailand just as Buddhism extends into Kelantan. Various Buddhist festivals are celebrated mostly around the temples located in Tumpat. The reclining Buddha at Wat Phothivian is a popular tourist attraction as is Southeast Asia's largest seated Buddha at Wat Machimmaram.

There are few trappings of modernity, so that Kelantan appeals to visitors who want a really relaxing holiday free from the cares of busy urban life. The main attraction in the historic heart of Kota Bharu is the bustling Central Market (Pasar Besar Siti Khadijah). This four-storey high market is one of the country's most photographed landmarks, where mostly female traders sell their fresh produce. Trishaw riders wait at the front entrance ready to take shoppers home. Other historic landmarks like the Cultural Centre, Handicraft Village, Istana Jahar and the Second World War Museum are within easy walking distance.

Left: It's not unusual to see colourful kites being flown along the East Coast.
Below: Visitors to the Handicraft Village and Craft Museum in Kota Bharu can buy souvenirs of local East Coast arts and crafts.
Opposite: Kota Bharu's famous enclosed market is always a favourite venue for visitors.

Its most popular beach is Moonlight Beach (Pantai Cahaya Bulan) north of Kota Bharu, while traditional arts and crafts shops selling *wau* (kites), *songket* and *batik* textiles, wood carvings, spinning tops and silver jewellery are located on the road leading to the beach.

Parts of Malaysia's best-known national park, Taman Negara, are located in Kelantan. The Kelantan section of the park is accessible from Gua Musang where a dirt road from Aring leads to a camp at Kuala Koh. The rivers here are well stocked with various species of fish and therefore are popular with those who enjoy fishing. However, few visitors venture here as the main access point for Taman Negara is via Kuala Tembeling in Pahang.

TERENGGANU

Terengganu has a long trading history that continues today, as it is now one of the most important Malaysian states for petroleum and petrochemicals production. Terengganu's state capital of Kuala Terengganu on the Terengganu River has been a trading port for centuries. By the beginning of the 18th century, Kuala Terengganu was well established as a centre of commerce dealing mainly in the export of pepper, gold, tin, camphor, sugar and gambier (a medicinal extract obtained from Acacia trees). Foreign vessels brought in the finest silks and other goods from China and nearby Indochina. These were re-exported from Kuala Terengganu by Chinese and European merchants. Pulau Duyong in the middle of the river is home to a boat-building industry that is as old as the port.

Kampung Cina (literally 'Chinese village'), located in the historic centre of Kuala Terengganu, is a significant national heritage site of shophouses established by the Chinese community in the late 19th century. It showcases a unique confluence of Malaysian cultural heritage. The original Kampung Cina settlers were directly engaged in the purchase and bartering of textiles,

metalwork and woodcraft produced by Malay artisans, who lived and worked in adjacent communities. They were allowed to trade by a system of *pajak* or concessions from the Terengganu rulers. The eclectic mix of shophouses along the waterfront here is bordered by Terengganu-styled timber houses. The surrounding district includes the Istana Maziah (the sultan's residence) and various urban Malay *kampungs*.

Several grand mosques are located in and around Kuala Terengganu. These include Abidin Mosque, Tengku Tengah Zaharah Mosque (Floating Mosque) and the Crystal Mosque. The Floating Mosque, made from white marble, is one of the state's most ornate. Built on a platform in the middle of a coastal lagoon 4 km (2½ miles) from Kuala Terengganu Town, it gives the impression of being suspended between the water and the sky.

In other parts of the state beaches, islands, forest and a constructed lake provide various recreational opportunities. The best beaches are located in the north-east of the peninsula around Rantau Abang. Various scenic fishing villages can also be found here of which Marang (not to be confused with Merang) is the most picturesque.

Colourful coral reefs and waters teeming with marine life off the Terengganu coastline lure divers who appreciate competitively-priced diving while staying in comfortable and mostly basic chalets. The first islands from the Thai border are the Perhentians (Kecil or Small Island and Besar or Big Island) which are accessible by ferry from Kuala Besut situated in the far north of the state. These are about the most laid-back of the East Coast islands. Their relaxed pace of life and lack of development ensures they appeal to budget travellers and divers who enjoy the clear waters of the South China Sea.

The most developed island is Redang where the surrounding sea is a marine park that offers protection to the marine life. While turtles are one of the most exciting sights here, especially when they come onto the beaches to lay their eggs, their numbers have declined significantly in recent years. One of the best snorkelling beaches is Tanjung Dalam, home to the Berjaya Resort.

Kapas, Bidong and Tenggol Islands to the south are not as developed and, therefore, not as crowded. Boats for Kapas, Bidong and the adjoining Gemia Islands depart from Kuala Terengganu or Marang to the south. The departure point for Pulau Tenggol is Kuala Dungan. Tenggol is the quietest of all but the diving and water visibility are superb and simple chalets are available. Like all the islands on the East Coast, the best time to visit is outside of the monsoon season, which brings rain from November to April.

Inland, Lake Kenyir, a constructed dam and lake covering 260 sq km (100 sq miles) was opened in 1985 by damming the Kenyir River. It is now a popular recreational area with several comfortable lodges located by the lake where watersports are popular. The locals love to jungle trek and picnic at one of several waterfalls at the weekend (which in this part of the world is Friday and Saturday).

There is also a Terengganu access to the large national park of Taman Negara but this is best left to adventurers guided by experienced walkers. The departure point is from the southern end of Lake Kenyir and visitors to this section of the park can also visit the large limestone caves of Bewah and Taat.

Above: Islands such as Pulau Rendang on the East Coast attract divers and sunseekers, who stay in a variety of accommodation from deluxe resorts to simple homestays.
Opposite top right: The East Coast has several sleepy fishing villages, such as Marang, which also serves as a departure port to the islands off the coast.
Opposite below left: Kuala Terengganu's Chinatown is entered via a colourful ceremonial gate.

PAHANG

The Main Range (or Titiwangsa Range) provides a natural divide and formidable barrier between the West and East Coasts. Much of the range lies in the state of Pahang, although there is also an extensive coastal strip from the state capital of Kuantan southwards to the East Coast border with Johor. The upland hill resorts of the Cameron Highlands, Fraser's Hill, Genting Highlands and Berjaya Hills at Bukit Tinggi are all located in the mountainous areas of Pahang.

Pahang is the largest state on peninsular Malaysia with a variety of landscapes ranging from montane vegetation in the uplands through to some of the county's most picturesque beaches and islands. Much of the tropical rainforest is in protected areas, which, while they are habitats for animals, also offer facilities for adventurous travellers. There are several parks worth visiting in Pahang including Endau-Rompin State Park, Kenong Rimba Park and Taman Negara. The latter is Malaysia's largest and best-known national park, which is home to vast tracts of lowland dipterocarp forest. While the park was established in 1939, its forests are estimated to be 130 million years old. Covering 4,343 sq km (1,677 sq miles) it extends over the three states of Pahang, Terengganu and Kelantan with the main access being from Kuala Tembeling in Pahang. From here, *sampan* (water taxi) journeys along the river provide access to the park headquarters at Kuala Tahan. It is the largest protected area of lowland rainforest in Malaysia.

The fauna and flora species list for Malaysia includes an estimated 10,000 plants, 200 mammals, 675 birds, 270 reptiles, 150,000 insects, 25,000 invertebrates and 250 freshwater fish. A large number of the flowering plants that have been identified in Malaysia are in Taman Negara. Scientists are still unravelling the mysteries of the tropical rainforest with many believing there is untold potential for drug discovery.

Apart from shooting the rapids and jungle trekking, a highlight of visiting Taman Negara is to walk the 450-m (492-yard) long canopy trail, which traverses the upper storey of the rainforest, 25 m (82 ft) above the ground. From here visitors get a unique perspective and a glimpse of birds, squirrels, shrews and reptiles. A boat journey along the Tahan River through huge overhanging trees to the waterfall at Lata Berkoh is another thrilling way of discovering the natural riches of the park.

Various trails provide opportunities for walks lasting from a few hours to the longest of all: the multi-day ascent of peninsular Malaysia's highest peak of Mount Tahan at 2,187 m (7,175 ft). All groups must be accompanied by an experienced guide on what is a long, hard, steep and often wet slog and all equipment must be carried.

The park is still home to its original inhabitants, the Orang Asli people, some of whom lead a traditional, semi-nomadic lifestyle of fishing and hunting. They are the only people allowed to hunt and forage in the park and many still use their preferred hunting weapons of poisoned darts and blowpipes.

Many travellers visit Malaysia because of its warm weather and year-round sunshine. For others, the heat and humidity can take its toll as was the case for the British in the days before air-conditioning. The only respite was to head to the cooler mountains. Fraser's Hill and the Cameron Highlands look very British with their mock-Tudor bungalows, landscaped gardens, open fireplaces and scones, cream and strawberry jam served for morning and afternoon teas. Several historic hotels and rest houses are synonymous with the cool highlands and have become almost as legendary as their locations. These include the Old Smokehouse and the Lakehouse in the Cameron Highlands and the Old Smokehouse at Fraser's Hill.

While the Cameron Highlands are a long way from the British Cotswolds, there is definitely an air of English refinement in this former hill station. Malaysia's most extensive hill station is located at an altitude of between 1,300 m (4,265 ft) and 1,829 m (6,000 ft), and covers a large area stretching along the road from Ringlet through the main towns of Tanah Rata, Brinchang and beyond. Parts of the mountains retain their colonial charm and offer a retreat to a more peaceful and sedate lifestyle.

Above: Many buildings in the Cameron Highlands, such as the Lakehouse, incorporate mock Tudor architecture.
Opposite: Visitors to Malaysia's largest national park, Taman Negara, can escape to secluded riverine settings to observe rainforest flora and fauna.

The Cameron Highlands are located on a forested plateau that is famous for tea plantations, temperate flowers and cool-climate vegetables and fruits, especially strawberries, which appear in various forms on restaurant menus.

Walking through the gardens and along fern-lined forest trails is a popular activity that is not as taxing as in the hot and humid lowlands (temperatures rarely drop below 10°C/50°F or climb above 21°C/70°F). This means lots of physical activities, such as hiking, golf on the 18-hole public course, tennis, cycling and sightseeing, are possible.

One of the most popular tourist attractions is the BOH Tea Plantation, producer of Malaysia's household favourite, Cameronian tea. There are many good locations in the highlands for a *teh tarik* (Malaysia's signature 'stretched' tea) with one of the best being the teahouse at BOH Tea called Tea'ria with its adjoining information centre on its Sungei Palas Plantation just out of Brinchang.

While similar to the Cameron Highlands, Fraser's Hill (also known as Bukit Fraser) at 1,500 m (5,000 ft) is much smaller and more sedate in nature. This highland retreat is closer to Kuala Lumpur (104 km/65 miles to the north-east) but accessible via a similar circuitous, narrow road that snakes up the mountain. Caution needs to be exercised on the narrow winding road as it is also a popular route for cyclist to train on.

There is an Old Smokehouse branch here which offers the most refined boutique accommodation in the mountain-top village although there is a range of accommodation available. Mountain walks, golf (nine holes), cycling, tennis, birdwatching and horse-riding complete the range of recreational activities. Its birdlife of some 270 species attracts enthusiastic birdwatchers from around the world.

Further south along the Titiwangsa Range there is a highland resort that is far from sedate. The vast mountaintop Resorts World Genting, frequently enshrouded in clouds, includes

the world's biggest accommodation complex with over 8,000 rooms located in various hotels. This integrated casino complex includes 20th Century Fox Studios Theme Park, extensive shopping outlets, over 80 dining options, indoor swimming pools and convention facilities.

Visitors can drive to the Genting, catch one of the shuttle buses or even reach the summit at 1,800 m (5,900 ft) from midway up the mountain via a cablecar. The Awana Resort halfway up the mountain has a wide range of recreational facilities including one of Malaysia's premier golf courses and playing here is certainly more refreshing than in the lowlands.

Above: Resorts World Genting is currently undergoing a transformation with 20th Century Fox Theme Park being one of its main attractions.
Opposite: The mountainous and forested Titiwangsa or Main Range is less than an hour's drive from Kuala Lumpur.

Berjaya Hills Resort at Bukit Tinggi is nearby and includes the French-themed village of Colmar Tropicale, the Chateau Spa and Organic Wellness Resort and a golf course. Colmar Tropicale at an altitude of 800 m (2,625 ft) features a cuckoo clock tower modelled on the Riquewihr Tower in Alsace. A traditional Japanese Tea House and temperate botanical gardens are located further up the hill from Colmar Tropicale at an altitude of 1,050 m (3,445 ft).

Several islands are located off the Pahang coastline of which Tioman Island is popular for its laid-back lifestyle and excellent diving. Tioman is the largest island in the group called Serbuat Islands to the east of Kuantan (most of these islands are located in the state of Johor but there are several in Pahang waters). One of Tioman's most appealing qualities is that there are no made-up roads or vehicles, so visitors have the choice of walking short distances or taking a boat. For snorkellers who want to progress to fully-fledged scuba divers, Tioman is a great place

to learn. There are several bays and beaches (mostly on the western shoreline) with Kampung Salang on the north-west coast, being one of the best for snorkelling. There are ferry services to Tioman from Mersing and Singapore.

Back on the mainland, there are several long flat beaches in Pahang. Cherating is one of the better known and it, too, has its own relaxed style. A sweeping bay of shallow water attracts most visitors but the winds also whip up the occasional good wave for ardent surfers. There is still very much a village atmosphere here with most accommodation being simple budget chalets with a few restaurants serving local food. Full resort facilities are available at Asia's first Club Med located just north of Cherating. Beaches south from Cherating to Kuantan, such as Balok, are venues for wind surfing and kite surfing especially when the monsoon winds are blowing.

Above: The East Coast of the peninsula is lined with near-deserted beaches or fishing villages where life moves at a slower pace than the West Coast.
Right: The waters surrounding Tioman Island are protected as a marine park and attract divers and snorkellers.

CHAPTER VI

SABAH

The Land Below the Wind

Sabah is often referred to as 'The Land Below the Wind', a name given to it by mariners who once used the trade winds to sail around the region, as it was the land just to the south of the typhoon zone. American author Agnes Newton Keith who lived in Sandakan with her husband (the Conservator of Forests in North Borneo during and after the Second World War) also wrote a book called *Land Below the Wind*. Preserved as it was during the war, their house in Sandakan is now a museum.

Left: Tun Sarakan Marine Park or Semporna Islands Park located just north-east of Semporna on Sabah's East Coast comprises eight islands and two reefs.

Sabah provides many opportunities for naturalists both on the land and in the adjoining waters. These include national parks, marine parks and wildlife reserves. Nature tourism is well-developed in Sabah and nature guides lead tours to Sabah's well-recognized natural areas such as Kinabalu Park, the Crocker Range, Danum Valley, Tabin Wildlife Reserve, Lower Kinabatangan River, Sepilok and Poring Hot Springs. Visitors can also learn more about the fascinating cultures of Sabah, relax on sun-drenched islands and beaches or participate in a range of thrilling adventures.

Sabah is one of Malaysia's largest states and home to a variety of ethnic people. Kota Kinabalu (simply known as 'KK') located by the South China Sea is the capital. Previously known as Jesselton, KK only became the state capital after the Second World War. It is a city of 500,000 residents (greater KK is 800,000) and is blessed with a location on the western side of the state that offers easy access to several offshore islands.

Kota Kinabalu International Airport is a busy airport for domestic flights (within Borneo), as well as air routes to the peninsula, Singapore and regional destinations, including Brunei, Bali, Hong Kong, Labuan, Singapore, Perth and Taipei. AirAsia, Malaysia Airlines and Malindo operate from Kuala Lumpur and other domestic airports while MASwings services destinations in Borneo.

Above: Some forests in Sabah are best accessed via rivers and streams using small boats.

Opposite top: Mount Kinabalu is one of the most recognizable geographical features on the island of Borneo as it is its highest mountain and now its flora and fauna have attained UNESCO World Heritage status.

Opposite below: The islands of Tunku Abdul Rahman National Park consisting of five islands are just a short boat ride from resorts like Sutera Harbour (pictured).

Gaya Street Sunday Market in central Kota Kinabalu is well worth a visit. Trading starts early and finishes around noon. While the locals seek out local Tenom coffee, fresh fruit and vegetables, and a 'cure-all' from a medicine man, tourists will be attracted to the local handicrafts and souvenirs.

The Filipino Market (officially Pasar Kraftangan) by the waterfront is popular with tourists for items such as clothes, *sarongs*, bags and seafood products. Not everything is Filipino with many souvenirs originating in Indonesia.

In the late afternoon, the setting sun creates a magical setting for those staying in resorts such as Sutera Harbour lining the foreshore of the capital. This large integrated property along the KK waterfront includes two resorts, a golf course, a marina and a country club complex.

Five islands comprising Tengku Abdul Rahman Park are a playground for the locals and visitors who catch boats for the short trip to enjoy swimming, snorkelling, diving, sailing and parasailing in and around the islands. Accommodation is available on some of the islands, while Sapi Island is the most popular as a day trip for snorkellers and swimmers. Underwater sea walking (air is fed into a protective helmet) is also possible here. Casuarina trees add to the charm of the islands as the noon sun is hot and their shade is much needed.

The North Borneo Steam Train (operated by Sutera Harbour Resort) is a nostalgic tourist train operating from Tanjung Aru to Papar and back. While there was once a short rail line in neighbouring Sarawak, the Sabah track appeals as it is the only remaining passenger railway on the island of Borneo. The steam train carries passengers on Wednesdays and Saturdays but only along part of the whole track that extends from Tanjung Aru all the way to Tenom. The steam train recreates the days when the train was one of the few ways to access the bounty of the Sabah rainforests.

Train enthusiasts should also travel on one of the trains operated by Sabah Railway that goes all the way to Tenom. On its 135-km (84-mile) journey which takes four hours, the train passes the fast-flowing Padas River. It is best to stay overnight in Tenom to see attractions such as the Tenom Agricultural Park (Taman Pertanian Sabah). This remote park in the Sabah interior covers 200 ha (494 acres). While many tropical plants, especially orchids, are on display, its primary aim is for research into various tropical plants like cacao, coffee and numerous fruit

species. The park is located some 15 km (9⅓ miles) south-east of Tenom in Lagud Seberang village.

Adventurous visitors travel to the Padas River for whitewater rafting, which, depending upon the water level, can be fast and furious. The 9-km (5½-mile) ride is thrilling and challenging. Getting there is half the fun as rafters have to catch the train from Beaufort to Tenom and get off in the forest along the way.

In December 2000, Kinabalu Park became the first Malaysian site to be inscribed on the UNESCO World Heritage List. At 4,095 m (13,435 ft), Mount Kinabalu is located here and is Malaysia's highest peak as well a centre of biodiversity with over 5,000 plant species identified within the 754-sq km (290-sq mile) park. Some plant species are found nowhere else and the montane flora that survives at the summit is distinctly different from that found in lower altitudes. Plants such as rhododendrons and orchids are a special attraction on Mount Kinabalu and many of these are displayed in the orchid gardens at Park Headquarters. Rare slipper orchids like *Paphiopedilum rothschildianum* flower profusely in the ideal growing conditions. This orchid is only found in limited areas around Mount Kinabalu making it one of the world's rarest. Pitcher plants are the other interesting species that are found along the trails. These carnivorous plants grow on nutrient-poor soils and the plant's energy is obtained through luring insects into a sticky liquid grave. Once entrapped, the insects break down to form food for the plant.

This volcanic outcrop of granite rock is visible from Kota Kinabalu, 90 km (56 miles) away. Exposed rock covers the summit but climatic conditions here are too cold for anything but the hardiest plant to survive. While the challenge of a two-day climb to the summit attracts adventurous travellers from around the world, the plant diversity and refreshingly cool air also appeal to those who are happy to stay in park accommodation and explore the forests around the park headquarters. There were once two routes to the summit but the Mesilau Trail has been suspended until further notice. The ascent along the main route normally involves an overnight stop in comfortable accommodation at the half-way station of Laban Rata (runners in the annual Mount Kinabalu International Climbathon staged in October cover the distance in just a few hours). Walkers head off in the darkness of the second morning to reach the Low's Peak summit in time for the sunrise. Clear mornings followed by cloudy and rainy afternoons are a common weather pattern at Mount Kinabalu and temperatures at the summit can fall to zero, so climbers need to be prepared with warm clothing.

While the climb doesn't require mountaineering skills, climbers need to be fit as it can be quite demanding and all groups require the services of a guide. The number of permits issued to climbers each day is limited. Climbers and adventurous visitors can also traverse the world's highest *via ferrata* (the climb assisted by a series of ropes and iron ladders) on parts of the mountain. The descent places different pressure on already weary muscles and can be just as exhausting as the walk up.

The Poring Hot Springs section of the park is located nearby where the pools of steaming spring water are the perfect place for recovering from the Kinabalu climb. Steaming water is piped into Japanese-style baths and while many come for the healthy properties of the sulphur-enriched waters, most come for relaxation and picnics. Not far from the pools there is a range of nature-based places to visit including waterfalls, a butterfly farm, caves, orchid gardens and a canopy walk through the uppermost layers of the rainforest. The canopy walk, 40 m (131 ft) above the ground, is for scientific research as well as recreation.

The Rafflesia Centre, one hour from KK near Tambunan, is one of the best places to see *Rafflesia* flowers (see page 23) as the rangers locate them within the forest. Expect to walk between 15 to 90 minutes to see them and it's best to ring ahead to ensure that some are in bloom.

Sandakan is the gateway to the state's north-east sector whose attractions include the Sepilok Orangutan Rehabilitation Centre, Gomantong Caves, Lower Kinabatangan River and the Rainforest Discovery Centre, all close to or within a few hours' drive of Sandakan. There is an airport on the outskirts of Sandakan and ferries operate between the port and the southern Philippines. Sandakan was the capital of British North Borneo (now Sabah) from 1883 until 1946 and was completely razed to the ground by Allied bombs at the end of the Second World War. What visitors see and experience today was built after the war.

Opposite top: Sunday morning's Gaya Street market is always lively with many exotic products sourced from the Kota Kinabalu hinterland.

Opposite below: Steam trains were once the only way to access towns such as Tenom – a tourist steam train now recreates part of that journey.

SEPILOK

ORANGUTAN SURVIVAL

Sepilok Orangutan Rehabilitation Centre on the outskirts of Sandakan was opened by the Sabah Wildlife Department in 1964 to care for orphaned animals and those that were being illegally kept as domestic pets. They are taught survival skills for their eventual return to the wild and while they move freely through the sanctuary, feeding times are an especially good time to see the animals.

Sepilok is located next to the Kabili-Sepilok Forest Reserve which covers an area of 4,300 ha (10,626 acres). Within the reserve there are good stands of lowland primary forest and mangrove swamps which are accessible via a series of trails.

Close by, the Rainforest Discovery Centre in the Forestry Research Centre is another area that is increasingly attracting visitors due to its elaborate rainforest canopy walkway high above the ground. There is a good interpretative display and a short, self-guided nature trail through the adjoining forests. While eagle-eyed visitors may spot the occasional shrew or squirrel, it is the birdlife in the rainforest canopy that is of most interest.

Turtle Islands National Park is a speck of land in the Sulu Sea off Sandakan, which is famous for its turtle hatchery and programme to release turtle hatchlings back to the open sea. Located 40 km (25 miles) off Sabah's northern coastline, the park is one of the region's best places for seeing wild turtles. The 1,760-ha (4,350-acre) park comprises three islands: Selingaan, Bakkungan Kechil and Gulisaan and its protection as a conservation area is making a valuable contribution to the survival of turtles. Selingaan Island is the only island accessible to the public but all three participate in the Sabah Parks turtle hatchery programme. Overnight visitor numbers are limited by the simple but comfortable accommodation available. As dusk arrives the turtles start landing on the sandy beach to lay their cache of eggs. Rangers lead tourists to watch the laborious task, then on to the hatchery to release the hatchlings in what are both great family activities.

Above: There are several opportunities to discover the tropical rainforest with the Rainforest Discovery Centre on the outskirts of Sandakan having an elevated walkway through the canopy.
Opposite: Lankayan north-west of Sandakan is a remote island that attracts divers.

Green and Hawksbill Turtles visit the island. Adult turtles can grow up to half a metre in length (1½ ft) and weigh up to 40 kg (88 lb). The rangers select just one turtle for visitors to observe. Each turtle lays about 100 eggs, then slowly crawls back to the Sulu Sea. In the morning the beach is lined with turtle tracks trailing into the water. The eggs are then transferred to the safety of a turtle hatchery by the rangers for the 50 to 60 day incubation period. The conservation area extends into neighbouring Philippines under a trans-boundary management arrangement between the two nations. There is an informative display and video presentation in the Visitors' Centre.

There are few beaches in the region with such fine white sands as the nearby small island of Lankayan. Being 90 minutes by fast boat from Sandakan, Lankayan is one of Malaysia's quietest outposts with just a few beachfront chalets in a Robinson Crusoe setting. Guests step from their beachfront chalet into the shallow waters and can watch Black-tip Sharks come in for a lunchtime feed. The diving at several sites in aquamarine waters is excellent and this is what attracts most visitors. Lankayan is part of an immense Marine Protected Area that is especially important as a nesting area for Green and Hawksbill Turtles. The Whale Shark season is from March to May.

Back on shore, the Kinabatangan River at 560 km (901 miles) is Sabah's largest and the floodplains of the lower reaches are one of Borneo's most species-rich habitats. Saved from logging and plantations, the 27,000-ha (66,718-acre) Kinabatangan Wildlife Sanctuary centred on Sukau includes the Menanggul River. The sanctuary is a 'forested island' surrounded by an ever-expanding sea of oil-palm plantations but it also offers one of the best wildlife experiences in Borneo. Sanctuaries like this are constantly under threat mostly through agricultural expansion in the form of lucrative oil-palm plantations.

Animals, such as the Flying Lemur, Slow Loris and Tarsier, are unknown to most but live here alongside other rarities, such as the Borneo Pygmy Elephant, Proboscis Monkey and Orangutan. Silvered Leaf-monkeys and Long-tailed Macaques are seen almost everyday with troops of them found in the sanctuary. Orangutans are not so commonly seen and if they are, they are mostly found alone unless it is a mother with her young. Silvered Leaf-monkeys are docile but the ever-active Long-tailed Macaques are commonly seen. Each afternoon, a small flotilla of boats carrying ecotourists heads off along a Kinabatangan tributary in search of wildlife. The Menanggul River is the heart of the Kinabatangan and one of Malaysia's hotspots for seeing wildlife.

The complex of Gomantong Caves is a place most people visit on the drive into the Kinabatangan. The caves have been known to the local people for decades as it is here that they have collected the prized swiflet nests, an essential and expensive ingredient in birds' nest soup. Long rattan ladders reach the most accessible cave crevices where only shafts of light breach the darkness of the caves. Visits are usually made with a guide.

Tabin Wildlife Reserve was established principally as a protected habitat for large mammals, such as the Sumatran Rhino and the Pygmy Elephant. So highly endangered is the former that it is rarely seen but some 25 individuals are thought to be surviving in the reserve. Secondary forest and an inner core of primary forest are home to many birds and other animals. Comfortable accommodation is available and there are several walks, waterfalls and streams to explore plus a few mud volcanoes of just a few metres in height.

The Borneo Rainforest Lodge in Danum Valley 83 km (52 miles) south-east of Lahad Datu offers a remote rainforest experience beside the tranquil Danum River. It is surrounded

by pristine lowland dipterocarp forest, which is the habitat for 275 bird species and 110 mammals including Orangutans.

Sabah's East Coast is sparsely settled with the main towns being Lahad Datu, Semporna and Tawau. Sipadan Island off Semporna on Sabah's north-east coast is Malaysia's only deep water oceanic island that is rated as one of the world's ten best dive sites. The small island in the Sulawesi Sea is the tip of a huge underwater sea volcano that rises up to 800 m (2,525 ft) above the sea floor. The visibility in the waters surrounding Sipadan and neighbouring Mabul are ideal for diving and to see the rich coral and marine life.

Situated at the northern tip of Borneo, few Malaysian destinations are as remote as Kudat. Head north from here and, apart from the even more remote Pulau Banggi, it is only the open Sulu Sea and then Palawan Island in the Philippines. Kudat offers remote beaches, clean air, an unhurried lifestyle, a pristine environment, scenic beauty and a tranquillity that can't be found in many other places. The Tip of Borneo near Matunggong has been developed into an attraction and although the beachfront is very scenic, there is very little to do here but pose under the Malaysian flag or swim along the deserted coastline of the South China Sea. There are various longhouses of the Rungus people that can be visited and some also offer an extended home-stay programme. Kudat is reached by a three-hour road journey north from KK or on scheduled flights on small aircraft.

Opposite: The Lower Kinabatangan River is one of the best places on Borneo to see wildlife. Specialist tour companies provide access along the main river and several tributaries.
Below: Gomantong Cave is the largest cave system in the Lower Kinabatangan and is divided into two accessible caves – Black Cave and White Cave.

LABUAN

Labuan Island is best known for offshore banking but it also has an interesting history and several tourist attractions. It is a trade-free zone, tax-free haven and an International Offshore Financial Centre (IOFC). Labuan is one of Malaysia's three Federal Territories and therefore, administered centrally. Labuan Financial Park is the focus for the IOFC located in the town centre, which was previously known as Victoria but is now called Bandar Labuan. Merchant bankers, lawyers and accountants regularly pass through town to get on with the business of doing business while enjoying duty-free beverages offered in several lively bars.

Labuan was once part of the Sultanate of Brunei but was ceded to the British in 1846. In 1848 it became a Crown Colony and James Brooke, the first Rajah of Sarawak, was also the Governor of Labuan. The British were attracted by deposits of coal needed to fuel steamships which were then plying the high seas. Several British companies mined the coal for over six decades and there was even a railway line from the coal mines at Tanjung Kubong to Victoria Port. The coal was depleted by 1911 but fishing and shipbuilding ensured the local economy continued. To this day, the Labuan Shipyard is a dominant feature, which is located just across the bay from the township and which continues to service the offshore petroleum industry.

For some international visitors, the island is close to their hearts as Labuan played a strategic regional role in the Second World War. Japanese forces occupied the island from 1941 to 1945. The liberation of Borneo by Australian troops from the 9th Division started in Labuan in June 1945 under the command of General Douglas MacArthur. A plaque in front of the small Labuan Museum marks the place where these forces landed. At the end of the Second World War, the Japanese surrendered to the Allied forces on Labuan. Other places of interest on the

island include the Surrender Point, Peace Park and Labuan War Cemetery where the remains of 3,908 Allied soldiers are buried.

Perhaps the biggest tourist attractions around Labuan are the wrecks submerged in shallow waters that offer reasonable underwater visibility. Three islands (Pulau Kuraman, P. Rusakan Kecil and P. Rusakan Besar) make up Labuan Marine Park and there are several interesting dive sites nearby. Pulau Papan, just south-east of Labuan, is another island that is popular with day-trippers who enjoy picnicking here, and swimming and snorkelling in the water.

Labuan Island at a little over 90 sq km (35 sq miles) is just 10 km (6.2 miles) off the Sabah/Brunei coast or 30 minutes by air from Kota Kinabalu. Duty-free shopping makes it appealing to holidaying East Malaysians (many visit as day-trippers on ferries that regularly depart from Kota Kinabalu or Limbang in Sarawak) and those from neighbouring Brunei. There are also direct flights to and from Kuala Lumpur.

Above: Travelling time for the ferries crossing from Kota Kinabalu to the duty-free island of Labuan is three hours.
Right: Some 1,800 Allied soldiers who died during the Second World War are buried on Labuan Island.
Opposite: Labuan Shipyard provides important support to boats servicing the oil and gas industry in East Malaysia.

CHAPTER VII

SARAWAK

Land of the Hornbills and Headhunters

Sarawak is Malaysia's other state on the island of Borneo and like Sabah, is a destination for those seeking cultural encounters and nature escapes.

Left: Rivers are an important part of life in Sarawak and for many communities they are their only lifeline to the outside world.

The capital Kuching is located on either side of the Kuching River. The waterfront strip on the eastern side is a beautifully landscaped esplanade that is the heart of Kuching's heritage and tourism district. This consists of temples, old warehouses and shoplots, and buildings of the former colonial government. As the sun rises, joggers and those getting in some exercise, work out along the thoroughfares. Visitors can take a leisurely stroll to explore the historic buildings, admire modern sculptures and to watch the musical fountain. The shaded river walk has interpretation signs along the way which detail the area's colourful history. The Main Bazaar facing the waterfront is lined with former *godowns* (warehouses) and shophouses selling souvenirs ranging from collectors' items to more accessible souvenirs, such as brassware, pottery, ceramics, tribal and ethnic arts and crafts, wood carvings, masks, blowpipes and shields.

The Court House was built in 1874 to bring together all government offices and provide the venue for all state ceremonies. State Council meetings were convened here from 1878 until 1973. Befitting its status, this is an impressive building with a sturdy ironwood roof that is decorated with beautiful engravings reflecting the impressive local art.

There's a *sampan* or water taxi terminal behind the Square Tower where visitors can cross the river. On the opposite bank, there's almost total darkness in the evening as the settlements here have been built some distance back from the riverfront. Fort Margherita, which is floodlit at night, is however very visible. Completed in 1879, Fort Margherita commands a strategic position along the Sarawak River. It was named after the second Rajah's wife and has been converted into a Police Museum displaying old cannons, cannon balls, guns, pistols, old police weapons, and scenes of hanging and other forms of criminal punishment. The new building here that dominates the riverscape is the futuristic, umbrella-shaped State Legislative Building.

Opened in 1891, the Sarawak Museum in Kuching has one of the region's best ethnography collections. The natural history display and that of the state's oil industry are fascinating. There is a comprehensive exhibition of traditional wood-carvings plus many faunal exhibits with some specimens dating back to Alfred Russel Wallace's expedition to the Malay Archipelago in the 1850s. Artefacts and even a life-sized model of the interior of a longhouse are housed here. The black-and-white photographs of the many tribes in Borneo are interesting but perhaps the most intriguing items are the weapons and body piercing instruments.

Sarawak's Cultural Village at Damai Beach, one hour from Kuching, is an exciting way to discover and appreciate some of Sarawak's many ethnic communities. The traditional homes of nine of the main communities are located around a lake surrounded by forest. Villagers put on displays and show visitors their varied ways of life. The village is also home to the internationally-recognized Rainforest World Music Festival. This festival is a three-day celebration of the world's best music with workshops and a friendly atmosphere to ensure its uniqueness among music festivals. While the world music artistes maybe unfamiliar to many, audiences are always assured

Left: Small wooden boats provide access to communities along the Sarawak River in Kuching and offer visitors one of the cheapest and liveliest river rides in the region.

Opposite: Sarawak's Cultural Village at Damai Beach is also the venue for the acclaimed Rainforest World Music Festival.

SARAWAK

that the musicians are leading exponents of their genre. It's never too late to acquire a taste for Mongolian throat singers or Polish Celtic bands.

For many visitors, Kuching is the entry point to an exploration of the interior of Sarawak. Miri in the north of the state is not only the gateway to Gunung Mulu National Park but it is also an oil-rich city that provides a service centre for offshore oil and a nightlife scene for those in neighbouring Brunei who travel here to let their hair down at the weekend. The Borneo Jazz Festival held here each May is a highlight of the tourism calendar.

While it is possible to take a longboat journey along the Melinau River into the park, most visitors choose to fly into Mulu from Miri. Mount (Gunung) Mulu National Park at 52, 866 ha (20,412 acres) is a UNESCO World Heritage Site protected for its astonishing ecological assets above the ground as well as limestone caves beneath the surface. Boats are used to reach some of the caves and several other park attractions in what is one of the state's largest national parks. There are many caves but only 30 have been explored and just four are open to the general public. Deer, Lang, Clearwater and Wind are the four main public caves with Deer Cave being the world's largest passage and Sarawak Chamber the world's largest cavern. It is a 6-km (3¾-mile) return walk to Deer and Lang Caves. The boardwalk to the caves passes through rainforest and across small streams before reaching Deer Cave named after the deer that take refuge here.

Boardwalks pass across the cave floor which is just as well as the ground is a mass of insects consuming mounds of guano (bat droppings). Wind Cave contains some excellent stalactites and stalagmites especially in the majestic King's Room and the cool breeze whistling through the caves is refreshing. Clearwater Cave further along the Melinau River is accessed via longboat or by walking a short distance from Wind Cave on a wooden walkway. On reaching the cave entrance, a 200-step climb is required before descending into a deep labyrinth with fast-flowing streams. These streams flow through a system that extends for over 100 km (62 miles).

At dusk, on every clear-skied evening, squadrons of bats fly out of the caves to forage in the forests. They form an indispensible part of the rainforest ecosystem as they help pollinate plants and the insect-eating bats keep insect numbers in check. This is one of nature's most astonishing sights; it's as if squadrons of bats are pulled out on a long piece of string for up to two hours.

On the boat journey to Clearwater and Wind Caves visitors usually stop at a Penan community to purchase locally-made handicrafts, such as beadwork. This community is sedentary but some Penan people are still nomadic and source most of their needs from the forests in the upper Baram and Rajang Rivers. These people have been the focus of international concerns over the loss of their habitat due to logging and clearing of land for agricultural use.

Left: Oil was first discovered in Malaysia in Miri and the original Oil Well Number One continued in production until 1972. The original wooden rig on Canada Hill adjoins an informative Petroleum Museum.
Opposite: Deer Cave in Mount Mulu National Park is huge being 2 km (1¼ miles) long and 90 m (295 ft) high.

In addition to the caves, there are some impressive rainforest, mountain climbing, river boating and visits to isolated communities to make it worth at least a three-day stay or even longer for the more adventurous.

The serrated limestone peaks of the mountain called 'The Pinnacles' are just some of the features of the park's high country that continues to challenge mountain climbers. It is also possible to climb to the peaks of Mount Api (1,750 m/5,740 ft) and Mulu (2,3716 m/7,795 ft) but this is a major commitment that needs to be done with an experienced local guide.

A completely different limestone cave system can be found one hour south of Miri. While Niah Caves have some impressive cave fauna, it is the archaeology that makes them so unique. Fragments of human skulls dating back 37,000 years have provided the earliest evidence of *Homo sapiens* in the region. The caves are accessible by an elevated boardwalk through the lowland dipterocarp forest.

Many remote communities in Sarawak are mostly only accessible by short scheduled flights operated by MASwings. This rural air service is a vital link for these communities as the alternatives are long river or boat journeys to civilization. The communities are identified on maps by the prefix 'Long', being an abbreviation for 'longhouse'.

Bario is located in the remote highlands of Sarawak and is only accessible by flights from Miri. At 1,500 m (4,921 ft) altitude, Bario has a refreshingly cool atmosphere. For the

adventuruous, there are several walks, such as the demanding four-hour trek across undulating hills to a longhouse called Pa' Lungun where it is possible to stay overnight in a guesthouse. Visitors can dine here on wild boar and Bario's famous upland rice.

Sarawak's tribal customs have been nurtured by many generations of communities that live all over the state from coastal river estuaries to the remotest rainforests in the interior. The only way to reach some is by travelling along jungle rivers in longboats and even today, a journey along the Rajang River is one of the many adventures that attract intrepid travellers. Fly into Sibu, then take a variety of crafts to Kapit and Belaga. The only means of river transport above Belaga is via a longboat.

Above: Water villages (*kampung air*) with houses built on stilts over the water can be found in many parts of Sarawak.
Left: In the villages it is not unusual to see people still wearing tribal clothes.
Opposite: Bamboo is one of the most versatile materials in the rainforest with some villages dependent upon bamboo bridges for access.

There are many other national parks in the state including Tanjung Datu, Bako, Similajau and Loagan Banut. It is possible for real adventurers to travel to the remotest parts of Sarawak for a jungle trek from one longhouse to another lasting several days. However, many travellers still appreciate their creature comforts while participating in soft adventure activities and they are catered for by more upmarket travel packages.

Batang Ai National Park in one of the remotest parts of Sarawak extends round a lake that was created by damming a river to generate hydropower thereby flooding what were once extensive stands of virgin rainforest. This is the land of former headhunters where Iban warriors were known for their fierce courage and complicated tribal customs. Visitors can stay in the Hilton Batang Ai Longhouse Resort or in traditional Iban longhouses in remote locations upstream from the dam wall.

During the heat of the day all strenuous activities are put on hold in the longhouses while the whole community takes shelter in the confines of the cooler interior. Later in the day, the villagers venture outside again to tend to their crops. Older community members relax, weave and repair tools and agricultural equipment. Along the verandah, women weave the intricate local *pua kumbu* cotton cloth that they also offer for sale. Others make *kandi* baskets, *tikai* mats and utilitarian items that are essential for growing rice.

SARAWAK

Above: Sleek wooden boats with a shallow draft and powered by an outboard motor or oars are the way many villagers move along the rivers of Sarawak.
Left: Batang Ai is a large constructed dam in Sarawak where the colours of the water reflect those of the rainforest.
Opposite: Bako National Park is the state's oldest national park and home to dramatic sandstone headlands.

Iban hospitality is best experienced at mealtimes when families gather in their individual sections of the longhouse next to their respective kitchens. Meals are eaten on a floor mat and include local dishes such as *pansoh manok* (bamboo chicken) and *asi pansoh* (rice in bamboo). Tea and *tuak* (rice wine) are often consumed during meals with the latter taken especially during the harvest festival.

157

RESOURCES

REFERENCES

Barber, A. 2009. *Penang under the East India Company 1786-1858*. Malaysia: AB&A.

Bowden, D. 2000. *Globetrotter Visitor's Guide Taman Negara – Malaysia's Premier National Park*. New Holland Publishers.

Bowden, D. 2013. *Enchanting Langkawi*. John Beaufoy Publishing.

Bowden, D. 2014. *Enchanting Borneo*. John Beaufoy Publishing.

Bowden, D. 2014. *Enchanting Malaysia*. John Beaufoy Publishing.

Bowden, D. 2014. *Enchanting Penang*. John Beaufoy Publishing.

Bowden, D., Hicks, N. and Shippen, M. 2013. *Southeast Asia: A Region Revealed*. John Beaufoy Publishing.

Kassem, K. and Madeja, E. 2014. *The Coral Triangle*. John Beaufoy Publishing.

Wallace, A. R. 1869. *The Malay Archipelago*. (reprinted 2015) John Beaufoy Publishing.

Davison, G., Gumal, M. & Payne, J. 2014. *Wild Malaysia*. John Beaufoy Publishing.

Phillipps, Q. & Phillipps, K. 3rd edition 2016. *Phillipps' Field Guide to the Birds of Borneo*. John Beaufoy Publishing.

Phillipps, Q. & Phillipps, K. 2016. *Phillipps' Field Guide to the Mammals of Borneo*. John Beaufoy Publishing.

Wong, T. S. 2014. *A Naturalist's Guide to the Birds of Borneo*. John Beaufoy Publishing.

Davison, G. & Yeap, C. A. 2013. *A Naturalist's Guide to the Birds of Malaysia*. John Beaufoy Publishing.

Kirton, L. 2014. *A Naturalist's Guide to the Butterflies of Peninsular Malaysia, Singapore & Thailand*. John Beaufoy Publishing.

WEBSITES

Keretapi Tanah Melayu Berhad (Malaysian Trains): www.ktmb.com.my

Sabah Tourism: www.sabahtourism.com

Sarawak Tourism: www.sarawaktourism.com

Tourism Malaysia: www.tourismmalaysia.gov.my

INDEX

Page numbers in *italic* denote illustrations.

A
Alor Star 116
Altingsburg Lighthouse 83
Arau 122
 Royal Mosque 122
 Royal Palace 122
arts and crafts 58–63, 96, 127, 140, 152, 155
Association of Southeast Asian Nations (ASEAN) 40
Ayer Keroh 97
 Orang Asli Museum 97
 Hutan Rekreasi Air Keroh 97
 Taman Mini Malaysia 97

B
Bakkungan Kechil Island 142
Bako National Park 24, *156*, *157*
Balik Pulau 115
Balok 134
Bario 154–5
bats 153
Baram River 153
Batang Ai 156, *157*
Batu Caves 4, *5*, *50*, 51, *82*, 83
beaches 22, 90, 99, 106, *108*, 109, 115, 116, *124*–*5*, 127, 128, 129, *134*, 143, 145
Berjaya Hills 130
Besar Island 128
Bewah Caves 129
Bidayuh people 46
 longhouses 46
Bidong Island 129
Borneo Jazz Festival 153
bridges, bamboo *154*, 155
Bukit Gasing 82
Bukit Larut 36, 106
Bukit Nanas Forest Reserve 76
Bukit Tinggi 133

C
Cameron Highlands 25, 36, 53, 130, *131*, 132
Canada Hill 153
Cape Rachardo Lighthouse 31
Cherating 22, 34, 134

Chettiars 43
Chinese 42–43, *44*–5, 48, 55, 109, 127
Chinese New Year *44*–5
Clearwater Cave 153
climate 36
Clouded Leopard 30
Coral Triangle 34
Crocker Range 138
cuisine 52–57, 83, 114, 122, 134, 140
Cyberjaya 79

D
Damai Beach 150, *151*
Danum River 144
Danum Valley 136, 144
Dayang Bunting Island *120*
Deer Cave *152*, 153
Desaru 99
dipterocarps *17*, *18*, 20, 76, 101, 115, 130, 145, 154
durians 53, *54*
Dusky Leaf Monkey 29

E
egrets 31

Cattle 33
 Intermediate *33*
elephants 26, 83, 101, 107, 144
Endau-Rompin National Park 26, 101, 130
epiphytes *20*, 22
ethnicity 41

F
False Gharial 34
Festival of Lights 50
flora and fauna 15–34, 130
 birds 31–33, 83, 120, 130, 132, 145
 amphibians 34, 120
 fish 130, 143
 invertebrates 130
 mammals 26–31, 101, 130, 142, 144, 145, 153
 plants *20*, 15–25, 141
 reptiles 34, 142–3
Forest Research Institute of Malaysia (FRIM) 83
forests 10, 15–21, 22, 24, 41, 76, 82, 92, 101, 104, 106–7, 115, 119, 120, 131, 132,

142, 144, 153, 154, 157
Fraser's Hill 31, 36, 130, 131, 132
fusion cooking 57

G
gaur 30, *31*
Gemia Island 129
Genting Highlands 130, 132, *133*
geography 15
gingers *21*
Gomantong Caves 31, 141, 144, *145*
Gombak River 65
Great Cave 10
Gulisaan Island 142
Gunung Ledang 101
Gunung Mulu National Park 22, 31, 153

H
history 10, 14, 36–40
hornbills 31, 46
 Oriental Pied 32, *33*
 Wreathed 32, *33*
Hungry Ghost festival 44

I
Iban people 14, *46*, 156
 longhouses 46, 156
Ipoh 22, *23*, 104
 Ipoh Railway Station *104*, 105
 Lost World of Tambun theme park 104
 Royal Ipoh Club 105
 St Michael's School 105
 Town Hall 104
Indians 43, 50, 56
Iskandar Malaysia 98

J
Johor 39, 98–101
Johor Bahru 98
 Jalan Tan Hiok Nee 99
 Sultan Abu Bakar Museum and Grand Palace 98
Johor islands 99
 Pulau Aur 99

K
Kabili-Sepilok Forest Reserve 142
Kadazan people 14, *46*
Kampung Kuantan 83
Kampung Salang 134
Kangar 122

State Mosque of Masjid Syed Alwi 122
Kapas Island 129
Kayan people 46
Kecil Island 128
Kedah 39, 48, 116–121
 Lake Pedu 116
Kelantan 39, 126–7
 Central Market *126*
 Handicraft Village *127*
 Istana Jahar 126
 Moonlight Beach 127
 Wat Machimmaram 126
 Wat Phothivian 126
Kenong Rimba Park 130
Kenyah people 46
Kenyir River 129
kerangas 24
Kinabalu Park 25, 138, 141
Kinabatangan Reserve 29
Kinabatangan River 15, 29, 138, 141, 144, *145*
Kinabatangan Wildlife Sanctuary 144
Kinta River 104
Klang River 65
Kota Bharu 39
Kota Kinabalu 40, 138
 Filipino Market 140
 Gaya Street Sunday Market *140*, 141
Kuala Besut 128
Kuala Dungan 129
Kuala Kangsar 105
 Perak Royal Museum *105*
 Ubudiah Mosque *105*
Kuala Lumpur 14, 39, 65–77
 Brickfields *76*, 77
 Changkat Bukit Bintang 71
 Dayabumi Complex *69*
 Hindu Temple *50*, 51
 Islamic Arts Museum of Malaysia 77
 Istana Negara *14*, 15
 Jalan Alor *12*, *13*, 71, *72*
 Jamek Mosque 65, *69*
 Kuala Lumpur City Centre (KLCC) *68–9*, 71
 Kuala Lumpur International Airport (KLIA) 66
 Kuala Lumpur Railway Station *6*, *7*, 66
 Malaysian F1 racing circuit 46, *47*
 Menara Kuala Lumpur *70*, 71, 76

Merdeka Square 66, *67*, 68
National Library 77
National Monument 40
National Mosque 77
National Science Centre 77
Parliament House 77
Petaling Street 71, *72*, 76
Petroleum Discovery Centre 71
Petronas Twin Towers *64–5*, 66, *69*, *70*, 71
Queen Victoria Fountain 66, *67*
Sepang International Circuit 82
shopping 76
Sri Mahamariamman Temple 50, 51
Sultan Abdul Samad Building *66*, 68
Kuala Perlis 122
Kuala Tembeling 130
Kuala Selangor 31, *83*
Kuala Selangor Nature Park 83
Kuala Tahan 130
Kuala Terengganu 127, 129
 Abidin Mosque 128
 Crystal Mosque 128
 Kampung Cina 127, *128*, 129
 Tengku Tengah Zaharah Mosque 128
Kuching 24, 150
 Court House 150
 Fort Margherita 150
 Main Bazaar 150
 Sarawak Museum 150
 State Legislative Building 150
 Tua Pek Khong Chinese Temple *48*, *49*
Kuching River 150
Kudat 145

L
Labuan Island 146–7
 ferry *147*
 Labuan Museum 146
 Labuan Shipyard *146*, 147
 Labuan War Cemetery *147*
 Peace Park 147
 wrecks 147
Labuan Marine Park 147
Lahad Datu 145
Lake Gardens 72, *73*, 74
 Asean Sculpture Park *74*
 National Monument *74*
 National Museum 74, *75*

Lake Kenyir 129
Lake Titiwangsa 76
Lang Cave 153
Langkawi 2, 4, 34, 106, 116
 beaches 116, *117*
 Datuk Kong Temple *48*
 Langkawi Geopark *119*
 Mount Machincang *119*
 resorts 116
 Temurun waterfalls *118*, 119
 wetlands 31
Lankayan Island 142, *143*
Lata Berkoh 131
Lenggong Archaeological Museum 10
Lenggong Valley 18
Loagan Bunut National Park 156
Long-tailed Macaque 26, *27*, 144
Low's Peak 22

M
Main (Titiwangsa) Range 130, *132*, 133
Malay people 42, 54
Malayan Sun Bear 30
Malayan Tiger *30*, 101, 107
mangroves *21*, 29, 31, 71, 83, 104, 113, 119–20, 142
Marang 128, 129
Matang 29
markets 53, 54, *55*, 76, 122, 126, 127, 140, *141*
Matunggong 145
Maxwell Hill (Bukit Larut) 36
Medan Portugis 97
Melaka 34, 36, 37, 39, 43, 48, 50, 92–97
 architecture *96*
 Baba and Nyonya Heritage Museum 97
 Christ Church *51*, 95
 Dutch Square *95*
 History and Ethnography Museum 97
 Jonker Street *95*
 Maritime Museum *97*
 Museum of Enduring Beauty 97
 Porto de Santiago 95
 protected zone *94*, 95
 Stadthuys 95
 St Paul's Church 95
 trishaws *97*
Melaka River *96*
Melanau people 46
Melinau River 153

Menanggul River 144
Merdeka Day 39
Minangkabau people 86–7
 architecture *87*, 88
Miri 153
monitor lizards 34
 Water Monitor *34*
Mount Kinabalu 15, 22, 31, 141
 plants 141
Mount Angsi 92
Mount Api 154
Mount Machincang *119*
Mount Mulu 154
Mount Mulu National Park 153–4
Mount Ophir 101
Mount Tahan 15, 131
Murut people 46

N
Negeri Sembilan 39, 86–92
 Istana Ampang Tinggi 90
 State Museum Complex *86*, *87*, 90
 State Secretariat Building *88*
Niah Caves 10, 154
Niah National Park 10

O
oil-palm crop 35
Orang Asli people 10, 14, 41, 131
Orang Sungai people 46
Orangutan *27*, *28*, 29, 141, 142, 144, 145

P
Padas River 141
Paedocypris progenetica 17
Pahang 39, 130–135
 islands 133
Pahang River 15
Painted Cave 10
Palawan Island 145
Pangkor Island *106*, *107*
Pasir Penambang 83
Payer Island 120
Penampang 47
 House of Skulls *47*
 Monsopiad Cultural Village *47*
Penan people 153
Penang *3*, *4*, *38*, *43*, *48*, *49*, 56, 107–115
 architecture *109*
 Arulmigu Balathandayuthapani Temple *51*
 Batu Ferringhi *108*, *109*, 113, 114
 Cheong Fatt Tze Mansion 112
 Eastern & Oriental Hotel *115*
 Fort Cornwallis 39, *108*, *109*
 George Town 109, *110*, 112, *113*
 Kapitan Keling Mosque *43*
 Komtar 112
 Penang City Hall 110, *111*
 Peranakan Mansion *110*, *111*
 Thai Buddist Temple *49*
Penang Hill 36, *114*
 Botanical Gardens 114, *115*
 funicular railway 114
Penang National Park 115
Perak 37, 39, 104–7
 rice growing *122*
Perak Man 10
Perhentians 128
Perlis 29, 120, *121*, 122–3
 Gua Kelarn 122
 Perlis State Park 122
 Wan Tangga Valley 122
Petaling Jaya 82
pitcher plants *24*
Poring Hot Springs *25*, 138, 141
Port Dickson 31, 90, *91*
Proboscis Monkey *26*, *27*, 29, 144
Pulau Banggi 145
Pulau Dayang Bunting 120
Pulau Duyong 127
Pulau Kecil 147
Pulau Kuraman 147
Pulau Payar Marine Park 120
Pulau Rusakan 147
Pulau Rusakan Besar 147
Puteri Harbour 101
Putrajaya 78–82
 Putra Mosque *80*
 Putrajaya Botanical Gardens 80
 Seri Gemilang Bridge *80*
 Seri Saujana Bridge 80, *81*
 Tuanku Mizan Zainal Abidin Mosque *79*

R
rafflesia *25*
Rafflesia Centre 141
railway travel, traditional *123*, *140*, 141
Rainforest World Music Festival 150, *151*
Rajang River 15, 153, 155
Rantau Abang 128
Redang Island 34, *129*
religion 48–51
rice crop 35
Royal Belum Forest 106
rubber crop 35
Rungus people 46, 145

S
Sabah 136–147
Saltwater Crocodile *34*
Sandakan 34, 137, 141
 Rainforest Discovery Centre *142*
Sapi Island 140
Sarawak 148–57
 boat transport *157*
 burial poles *46*
 Burmese Buddist Temple *49*
 Cultural Village 150
 water villages *155*
Sarawak River 150
Selangor 39, 82–83
Selangor River 83
Selingaan Island 142
Semporna 145
Sepilok 29, 138, 142–5
Sepilok Orangutan Rehabilitation Centre 141, 142
Serbuat Islands 133
Seremban 86, *88*, *89*
 Seremban Lake Gardens *90*
Seri Menanti 86, 88, 90, 92
 Istana Lama *92*, *93*
Shah Alam 82
 Shah Alam Botanical Gardens 82
 Sultan Salahuddin Abdul Aziz Mosque *48*, *49*, 82
Siamang 29
Silvered-leaf Monkey *26*, *27*, 144
Similajau National Park 156
Sipadan Island 145
sports 47, 120
Straits of Johor *98*, *99*
Straits of Malacca 31, 37, 83, 86, 97, 120
Stump-tailed Macaque 29
Sumatran Rhinoceros *26*, 101, 107
swifts and swiftlets 31, 144

T
Taat Caves 129
Tabin Wildlife Reserve *26*, 138, 144
Tahan River 131
Taiping 106
 Lake Gardens 106
 Taiping Museum 106
Taman Negara National Park 15, 17, 30, 31, 127, 129, *130*, 131
Tanjung Dalam 129
Tanjung Datu National Park 156
Tapir 30, 101
Tawau 145
Temenggor Dam 107
Temple Cave *50*, 51
Templer's Park 83
Tenggol Island 129
Tengku Abdul Rahman Park 140
Tenom Agricultural Park 140
Terengganu 39, 127–9
 islands 128–9
Terengganu River 127
Thaipusam festival *51*, 82
Tioman Island 133, 134–5
Titiwangsa Range 17, 130
tree ferns *21*
Tunku Abdul Rahman National Park 138, *139*
Turtle Island 34
Turtle Islands National Park 142
turtles 34, 142–3

U
Ulu Bendul forest reserve 88, 92

W
water villages *155*
Wesak Day 49
White-handed Gibbon 101
Wind Cave 153

Z
Zoo Negara 82–83